IMAGES
of Rail

RAILROADS OF
MONMOUTH COUNTY

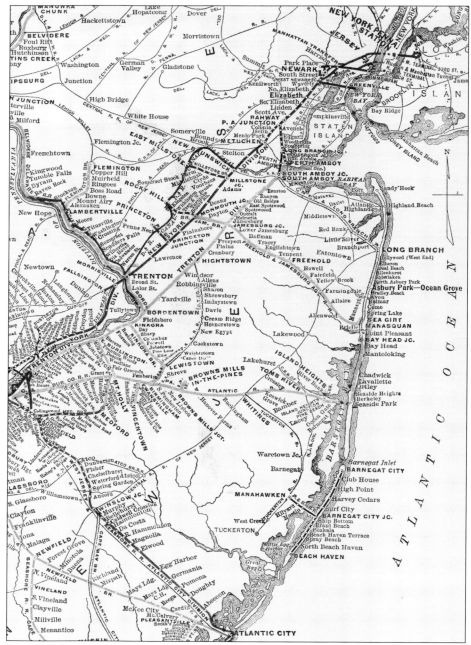

Pictured here is the New Jersey railroad system in 1917.

On the cover: No other image represents the railroads of Monmouth County better than this view taken from the grandstand at Monmouth Park Racetrack. Both major railroads are represented side by side at Monmouth Park Racetrack's special rail terminal where they delivered thousands of people eager to place their bets. These two fierce competitors reluctantly shared the main rail line through Monmouth County. (Courtesy James Raftery Turfotos, Joel Rosenbaum collection.)

IMAGES
of Rail

RAILROADS OF
MONMOUTH COUNTY

Tom Gallo and William B. Longo

ARCADIA
PUBLISHING

This book is dedicated to the late George Lester Whitfield.

CONTENTS

ACKNOWLEDGMENTS

The authors express their sincere thanks to those who offered use of their photographs, provided information or research confirmation, proofread, and many other aspects that go into a publication of quality. A special thanks goes to longtime friend and author Joel Rosenbaum for selfless time and material contributions. Thanks also go to Shirley Bennett, Bob's Photos, Jim Boyle, John Brinckmann, William J. Coxey, Dorn's Classic Images, Leonard Falkowski, James and Janet Gallo, Tom Gallo Sr., Charlie Gebhardt, Robert Hoeft, Robert Hooper, Keyport Historical Society, Frank C. Kozempel, Howard B. Morris, Motor Bus Society, North Jersey Electric Railway Historical Society, Francis Palmer, Robert Pennisi and Railroad Avenue Enterprises, James Raftery Turf Photos, G. Jack Raymus, Frank Reilly, Pete Rickerhauser, Ralph Shelhammer, John Sorge, Don Wood, George E. Votava, Marie and Norman Wright, Martin S. Zak, and last but not least, the Arcadia team.

This book is dedicated to the late George Lester Whitfield. Les began a 45-year career working for the Central Railroad of New Jersey. Starting out as a ticket agent/block operator, he rose through the ranks, retiring in 1985 as a trainmaster. He mostly lived in Monmouth County, settling in Highlands next to the Twin Lights within sight of the Seashore branch. His collection represented the changes from steam-era industrialized America to today's modern-day world and was offered to us by his family. Many of the details herein would have been lost except for his sense of preservation and his children's wishes to share his meticulous chronology. The authors appreciate their thoughtfulness.

The images herein are for educational and enjoyment purposes. Readers should be aware that the railroads and other locations shown may not be trespassed upon nor should access be attempted without permission of the owners.

INTRODUCTION

By the 1880s, every coastal location in Monmouth County from Sandy Hook in the north to Manasquan in the south was served by a railroad line. Trains moved people to and from New York, Newark, and Philadelphia, as well as short local trips. These rail connections played a major role in developing Monmouth County's ocean beaches into pleasant summer resorts. The dependable rail service began the transformation of the county from a tourist destination and farmland into a desirable place to live.

Monmouth County's first railroad, the Freehold and Jamesburg Agricultural Railroad (F&J), was built in 1853. It connected the county seat at Freehold with New Jersey's very first railroad, the Camden and Amboy (C&A), at Jamesburg. New railroads were hard-pressed to gain trust and therefore capital for construction and equipment to operate, often borrowing from existing companies. The C&A lent the F&J equipment so it could begin service, for a fee of course. The F&J was gradually expanded and then came under control of the Pennsylvania Railroad (PRR), a powerful growing collection of rail lines, giving it broader service destinations. The F&J provided through service from Philadelphia and Trenton to Long Branch and Red Bank via Monmouth Junction, Freehold, and Sea Girt.

The first railroad to reach Long Branch was the Raritan and Delaware Bay in 1861. From Port Monmouth on the Raritan Bay, connecting service to and from New York required a ride on a steamboat, many of which the railroads owned and operated themselves. Long Branch was reached by a spur track from the main line at Eatontown.

While the early steamboat connections to the train were pleasant in good weather and the warm summer months, inclement and severe weather could make the trip dangerous. Ice conditions often forced suspended service with no alternative. There were few paved highways.

This fostered the absolute need for a dependable, all-weather rail route from New York City to the county's northern coast, resulting in the construction of the New York and Long Branch Railroad (NY&LB). Completed to Long Branch in 1875 by the Central Railroad Company of New Jersey (CNJ), the NY&LB was then operated typically as a separate company due to the financial uncertainty of the new rail line. This protected the parent holding companies' other holdings from failures. One major undertaking to connect the NY&LB to northern New Jersey and New York City points was the need for a bridge over the mighty and well-navigated Raritan River at South Amboy. The CNJ constructed the then-largest drawbridge of its type in the world to reach the shore of Perth Amboy and those northern connections. Down the shore on the opposite end of the NY&LB, its tracks were extended to Bay Head Junction in 1882, connecting with a PRR line to Camden through Toms River and Seaside Park.

Initially the CNJ exclusively owned the NY&LB; however, with the PRR threatening to build a competing line, the two railroads agreed to share the line, with the PRR equally owning one half. This arrangement benefited both railroads as they double-tracked the entire route and

made improvements. One aspect of the agreement called for the CNJ to handle all infrastructure maintenance and the PRR to perform accounting. Further, each railroad operated its own trains and owned its own equipment. The NY&LB had some employees of its own, including ticket agents, tower operators, and crossing gate watchmen, however, it did not own any equipment.

When the PRR completed its Hudson River tunnels and magnificent station in New York City in 1910, travelers and commuters to and from Monmouth County had many options. They could ride a PRR train directly into Manhattan or continue using its Exchange Place, Jersey City terminal and ferries, or ride the CNJ to Jersey City to catch a ferry over the Hudson River. In the summer they could also ride CNJ trains from Asbury Park, Long Branch, and Sea Bright to the Atlantic Highlands Pier and climb aboard one of CNJ's Sandy Hook route steamboats to Manhattan. More options in the quilted system of tracks included CNJ trains from Freehold and East Long Branch to Jersey City/New York City and PRR trains from Long Branch and Toms River to Camden and Philadelphia, and more options from Long Branch to Freehold, Trenton, and Philadelphia.

Rail passenger service in Monmouth County reached its zenith on February 21, 1929, when the CNJ's *Blue Comet* began service from Jersey City to Atlantic City. Red Bank was an important station stop and junction for the fast train and was the only Monmouth County town initially served. The *Blue Comet* was specially marketed with its painted colors of Packard blue, Jersey cream, and dark blue to represent the sky, sand, and sea of the Jersey shore. The train's color arrangement, when in motion, gave the *Blue Comet* the appearance of a comet streaking through space to bystanders.

The building of better roads and superhighways in the 1950s sped up bus and automobile travel time from the New York metropolitan area to Monmouth County. Many World War II veterans took advantage of the GI Bill, improving their economic status through education and VA mortgages. These programs and other factors resulted in the conversion of Monmouth County farms into housing developments with two-car garages. The new prosperity hurt the summer rail excursion services and resulted in some of the lines losing passenger service and being abandoned. The housing developments also turned some of the lightly used stations such as Middletown and Hazlet into major commuter stops.

Technology changes offered the railroads a fairly new motive power form referred to as diesel electrics. A diesel engine simply defined generates electricity, which powers special wheels (trucks) that provide tractive effort and turn the wheels. These units were simple to use, as they needed no water tanks, coaling facilities, and expensive track arrangements for turning unidirectional steam engines. Operation and maintenance costs were greatly reduced. The CNJ completely dieselized in 1954, followed by the PRR by 1957. Between those years, as the transition between steam and diesel took place, watching trains on the NY&LB was better than a department store window Lionel model train Christmas display.

While South Amboy, Point Pleasant, and Bay Head Junction are outside of Monmouth County, they have played an important role in the county's railroad operations. South Amboy was once an important PRR engine-change and maintenance facility on the NY&LB. The electric overhead power system there through to New York City allowed the PRR to remove steam, later diesel, engines and couple sleek electric engines to whisk commuters to work. Prior to the Aldene Plan of 1967, the PRR changed some engines in Rahway. Point Pleasant once served as the end terminal yards for NY&LB trains. This was later relocated one mile south to Bay Head Junction.

In the late 1960s, the railroads were reduced in importance as a mover of people and goods nationwide. Consolidation of duplicate services and mergers began to take place. In 1967, under the Aldene Plan, CNJ passengers were rerouted into Newark's Pennsylvania Station. This allowed CNJ to close its Jersey City and Broad Street Newark stations and eliminate the aging Hudson Ferry service fleet. In 1968, the PRR merged with the New York Central, becoming Penn Central. By 1976, all the major railroads of New Jersey ceased to exist and became the Consolidated Railroad Corporation.

One

The New York and Long Branch Railroad

An 1889 map of Monmouth County shows the railroad grid. Clockwise from the top center, the county perimeter follows from Matawan and Keyport eastward along the bay then southward along the ocean shorelines to the Manasquan River. Working westward is lower Howell Township just north of Lakewood. To the far west, the county boundary has an unusual jutting leg, not fully shown, within Upper Freehold Township ending at Hornerstown to the southwest and Allentown to the northwest. (Courtesy Tom Gallo.)

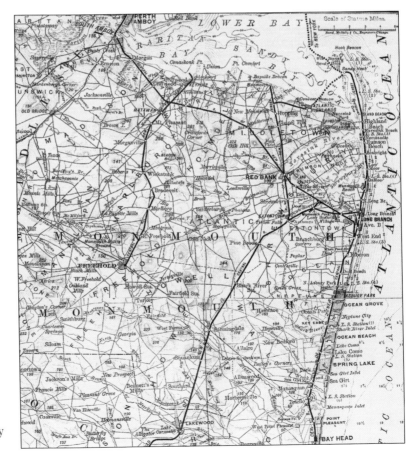

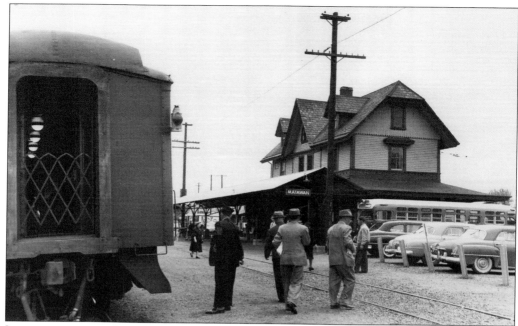

Junction stations such as this 1956 Matawan setting were key locations for commuter transfers to connecting branch lines, locations for the interchange of freight goods, and in many cases hubs of local commerce activity. The hind end of a southbound train with its kerosene marker lamp displayed and conductor signaling to depart was typical, as seen here. Passengers are walking to an out-of-view connection to the Seashore branch and the Freehold bus (right). Railroads contracted local bus service where train operation lost money. (Courtesy Don Wood.)

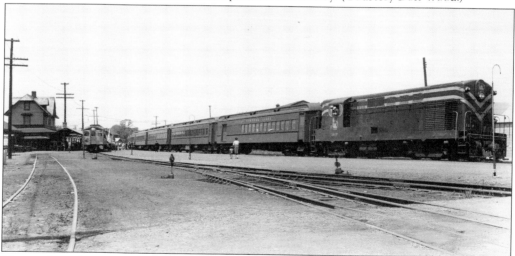

The engineer leans out for a clear view of the discharging passengers boarding the Seashore branch shuttle. The engine is a diesel electric unit known as a Baby Trainmaster. Built by the Fairbanks Morse Company beginning in 1949, these versatile units, with less horsepower than their big brothers, the Trainmasters, could be found working in most locations around the CNJ system. In the foreground, the remains of a once well-maintained track system are serviceable but not picture perfect. (Courtesy George E. Votava.)

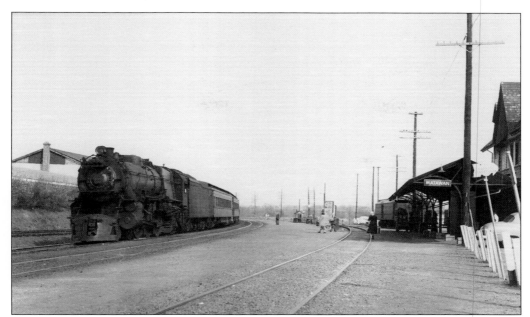

A few people walk toward a waiting northbound Pennsylvania Railroad (PRR) train with steam engine No. 3751. The conductor is in the middle of the scene. There are no tree leaves, and the dress of the few customers indicates a cold-season midday or a weekend schedule. The Railway Post Office car (RPO) setting to the right will be loaded with local mailbags. (More about mail trains later.) (Courtesy Railroad Avenue Enterprises.)

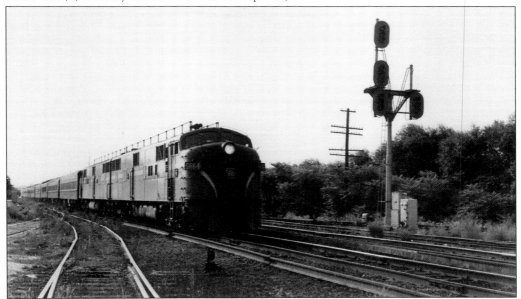

PRR diesels paired up as a double-header to bring a string of coaches into Matawan past the signal mast that protected yard and station track movements from the busy New York and Long Branch (NY&LB) main tracks. The tracks and switches in this area were controlled by an interlocking system and a towerman 24 hours a day, seven days a week. The system, operated correctly, prevented any conflicting train movement. (Courtesy Tom Gallo.)

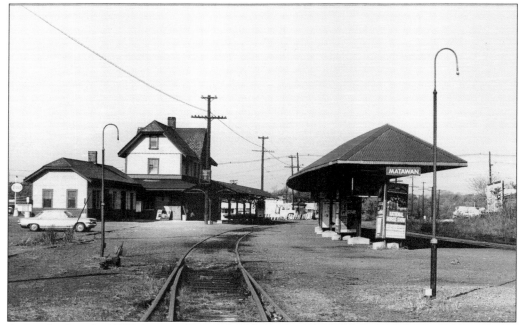

A close look at the 1875 Matawan Station building reveals hints of its once majestic place in time. The two-story Victorian building accommodated a ticket office and waiting room. The agent in earlier times was allowed to live on the second floor with family, basically serving the railroad 24 hours a day. This station design was used in at least 12 other Central Railroad Company of New Jersey (CNJ) stations. The building to the left was added later to handle railroad mail and express needs. Advertisement posters displayed on the canopy supports brought in revenue from advertising agencies. (Courtesy William J. Coxey.)

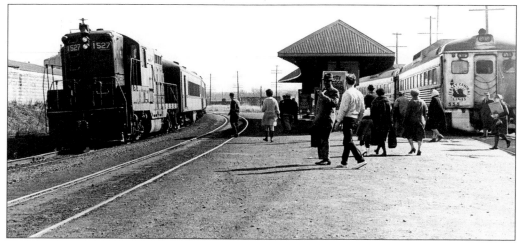

It is February 1966. Passengers exit the warm waiting room and board the CNJ train. CNJ purchased General Electric's (EMD) General Purpose locomotives in their GP series. This is GP7 No. 1527. At 1,500 horsepower, this bidirectional unit could be coupled to several more or operate alone. The CNJ needed this versatility due to its heavy-freight long-haul and short-haul business and light branch line services. Flexibility and utilization were the key to reducing operating costs. (Courtesy Railroad Avenue Enterprises, photograph by Bob Pennisi.)

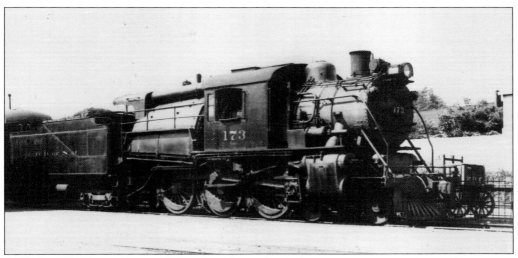

CNJ Camelbacks, nicknamed for their hump-backed appearance, were the pulling power backbone of the CNJ in the coal and steam era. Setting on a track off the NY&LB main, this short train will provide a connection to either the Freehold or Seashore branch. The operating cab is empty, indicating the connection may be a while. CNJ veteran Bob Hoeft explained that crews were allowed rest time in the second floor of the Matawan station. This was, of course, years after the agent was no longer allowed to live there. (Courtesy Tom Gallo.)

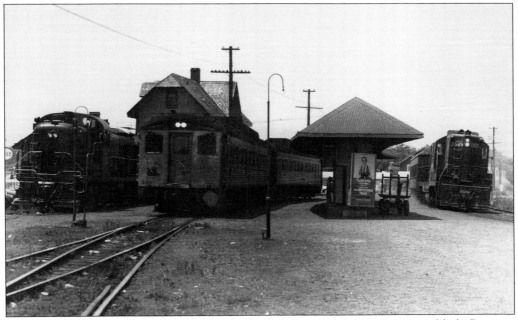

Three trains simultaneously at the station exemplified Matawan's status as a rail hub. Business was slowing in 1966 when CNJ GP7 No. 1525 entered to discharge customers. Many will drive home. Rail riders from Keyport to Atlantic Highlands boarded the pair of CNJ's rail diesel cars or RDCs. RDC No. 554 will lead the 10-mile trip on the Seashore branch, once permission is given by the signal noted earlier to depart. On the left is a local freight drill, CNJ No. 1541, staying out of the way for now. (Courtesy North Jersey Electric Railway Historical Association.)

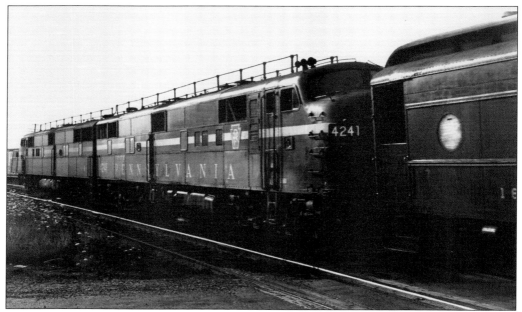

PRR No. 4241, an EMD E8, had very visible radio antennas along its top. Much more cumbersome than today's antennae, they connected to onboard radios, which provided engineers and dispatchers quicker communications with each other. Any changes or unforeseen conditions could be reported immediately. Staffed control towers at interlockings along the way would be replaced by radios and remote interlocking controls. But not for a while longer, it is only July 1966. (Courtesy Tom Gallo.)

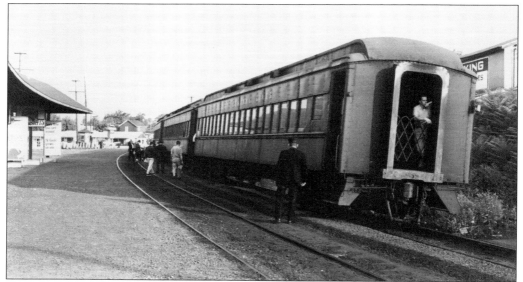

A CNJ train heading for Jersey City is stopped for boarding. The shadow direction cast by a low sun indicates it is early morning. The few riders and lack of neckties indicate it is a weekend. A man on board in the vestibule enjoyed a cool breeze after departure. There was no air-conditioning on board these still-in-service 1920-era coaches. Open the window, please. (Courtesy Tom Gallo.)

It is around 1954. Before trains approached the busier road crossings, watchmen received an alarm bell inside their shanties. Using cranking levers, they manually lowered wooden gates that stretched across the open roads to keep errant cars from tangling with trains. Bill Davis, left, was a watchman at Main Street Matawan for years. His straw hat provided some relief from the hot sun. This was an all-weather job with no cover, although some shanties did have the levers inside. When rain soaked the wooden gates, metal counterweights were added to keep perfect balance, easing the repetitious cranking process. (Courtesy Tom Gallo.)

Atlantic Avenue is located on the east side of Matawan station. Shanties served as an on-duty home. The difference at this crossing is there are no gates to lower. Likely due to the seven main and yard tracks and forward and reversing movements of freight and baggage drills, this watchman merely walked out in the road with a round stop sign on a pole. The sign is leaning on the shanty. He could never have survived the up and down cranking that would have been required at this crossing. Crossings were staffed at all times without fail. (Courtesy Tom Gallo.)

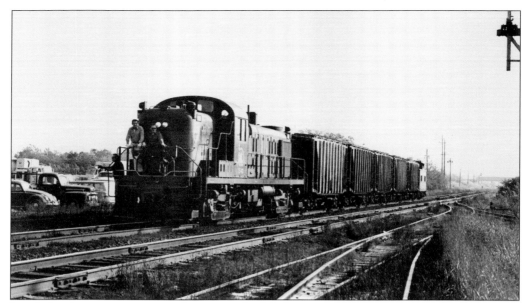

Local freight trains move in between scheduled trains. They are dispatched from yards strategically placed at interchange points to complete delivery of cars with shipments or retrieve outgoing goods. The crew of the CNJ local freight train named QVX, from Red Bank in this 1968 scene, enjoys fresh air on the front of RS3 (road switcher) No. 1542. In tow are five sand hoppers and a caboose, all heading for Midland Glass in Cliffwood, the next town and the last in northeastern Monmouth County. (Courtesy William J. Coxey.)

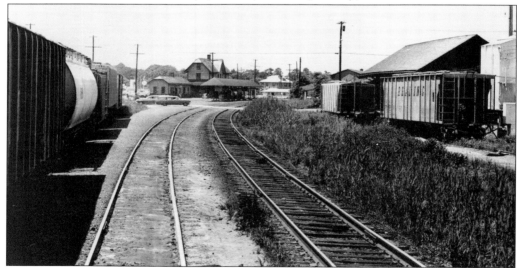

An arriving engineer's view of Matawan shows a typical scene. To the left are waiting cars dropped off by a through freight train from northern interchange yards such as Elizabethport. Local freights draw from and add to these waiting strings of cars. To the right is Duncan Thecker, a cement company that received tons of sand and cement for sale to local builders. Two hoppers served as dry storage until the aggregates are drawn from the car bottom. The aggregates were then air pumped up to a tower, combined with water, mixed, and loaded into waiting cement trucks. (Courtesy William J. Coxey.)

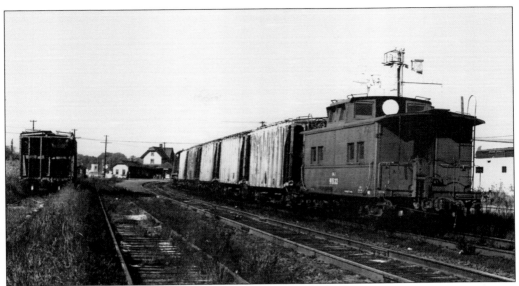

The crew has assembled the cars it needs and departs for Cliffwood. Protecting the rear of the train is CNJ caboose No. 91532. Cabooses were mostly red, the color used as a stop indicator on railroads. An errant approaching train might have a chance to stop in time if the engineer saw the red caboose soon enough. The yellow circle atop the cupola was applied in later years as the cabooses took a grimy dull look reducing visibility. Cabooses were working offices for crews to do paperwork and travel safely from point to point. (Courtesy William J. Coxey.)

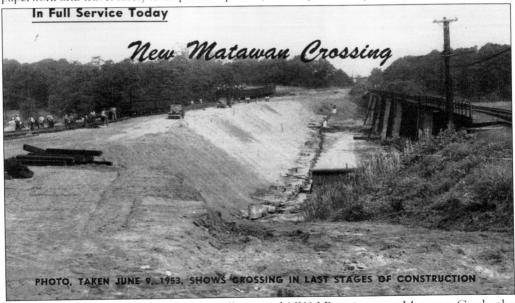

In Full Service Today

New Matawan Crossing

PHOTO, TAKEN JUNE 9, 1953, SHOWS CROSSING IN LAST STAGES OF CONSTRUCTION

A high and long wooden trestle originally carried NY&LB trains over Matawan Creek, the site of the famous shark attacks of 1916. A December 6, 1946, fire resulted in a quick 10-day reconstruction, however, with only one track versus the original two. A storm of commuter protest, generated by the 1951 *Broker* wreck off a trestle, forced the NY&LB to build a solid-fill right-of-way (left). The single-track trestle also had spring-operated switches, forcing drilling freight trains to make reverse moves in a cautious fashion. (Courtesy William J. Coxey.)

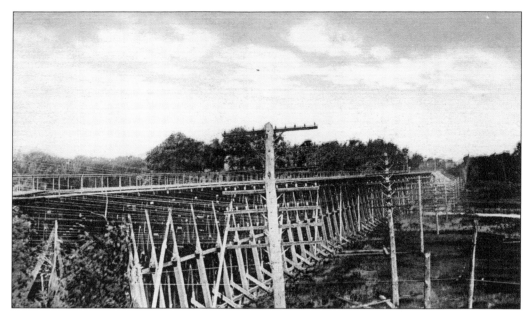

This postcard view of the original trestle shows the dramatic structure. After the fill and new double-track line were completed, a celebration and special train marked the opening of Matawan Crossing. On September 14, 1953, Earle T. Moore, president of the CNJ, and Mike Strollo, well-respected superintendent of the NY&LB, rode aboard with local dignitaries to celebrate. (Courtesy CNJ Coupler.)

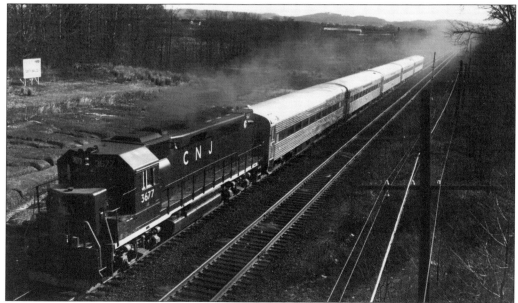

Twenty-three years later, CNJ GP40P and five stainless steel coaches purchased secondhand from a western railroad accelerate over the fill just behind the last car. The area by the white sign has yet to grow back, marking the original track alignment that approached the feared trestle. Remnants of the trestle pilings, cut just above the low tide mark, are visible today at low tide, outlasting the elements and confirming they were structure worthy. (Courtesy Don Wood.)

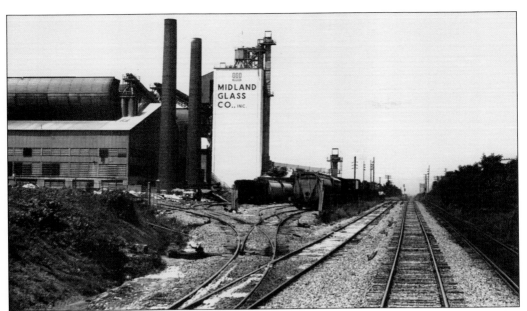

A half-mile away, Midland Glass employed many local residents, producing glass bottles. In this 1970 view, the CNJ could drill loaded sand hoppers in and out of the track work (left) setting strings of loads in and taking empties out. The two tracks to the right are the NY&LB main line. The track to their left is a siding with switches at both ends. This allowed long strings to be moved in and out either way and to relocate the locomotive to the end of the train desired. Midland Glass became Anchor Glass before closing. (Courtesy William J. Coxey.)

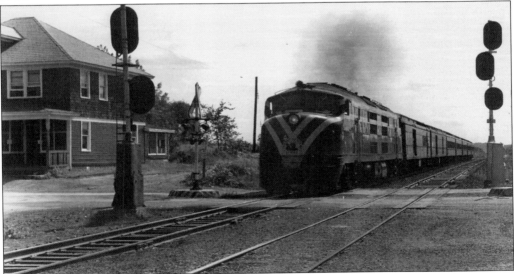

Cliffwood Avenue was not a busy road in this late-1950s image. A CNJ Baldwin-built locomotive hauls seven cars northward. First behind the locomotive is an RPO, a mail-handling facility on wheels. On the sides of these RPOs were arms that would "grab" a sack of mail hanging on a mail crane at less-served stations. Tom Gallo Sr. recalls Mrs. Gussy McGrath setting the bag up daily and watching the train clip on as it went by. He recalls the bag dropping only one time. Delivery of the mail when not stopping was to just throw the bag off. (Courtesy CNJ.)

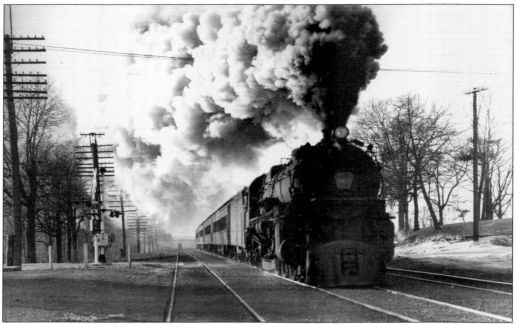

A PRR New York–Bay Head Junction local roars through Hazlet on a late-winter afternoon in 1955. The short weekend train is crossing Keyport-Holmdel Road. Note the inexpensive cinder platform in the foreground, made from the very ashes of the coal-powered steam engines, reused by financially stressed railroads. Author William B. Longo's grandfather brought him here at age five to enjoy the sights and sounds. K4s No. 4417 was scrapped later that year. (Courtesy Don Wood, Joel Rosenbaum collection.)

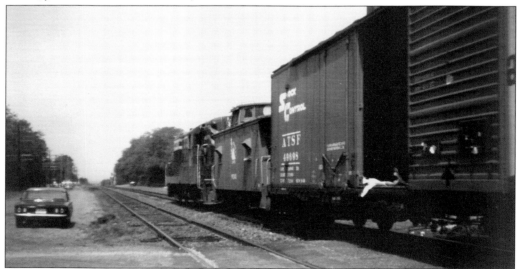

Also at Hazlet, a CNJ local drill heads back to Matawan, bringing at least one empty boxcar for reassignment. Few commuters used this station, a township of mostly open and farm land, until a 1960 development surge advanced residency into the tens of thousands. A ketchup factory once stood just beyond the train, taking full advantage of fresh locally grown tomato crops. (Courtesy Tom Gallo.)

CNJ maintenance of way crane No. 251m, built by American Crane Company, sits on the Hazlet siding in 1970. The siding was used to deliver goods to Swartzel's Hardware and Feed Store. Behind it rests a hopper, remnants of derailed CNJ freight SJ2, which ripped up half a mile of track, tossing freight cars on their sides. The crane was used to lift cars back onto their wheels (trucks) to be towed back to a repair shop. Primarily the crane was used to repair the tracks. (Courtesy Tom Gallo.)

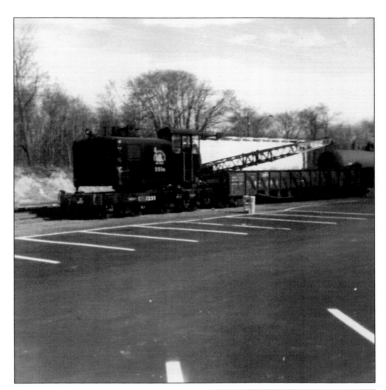

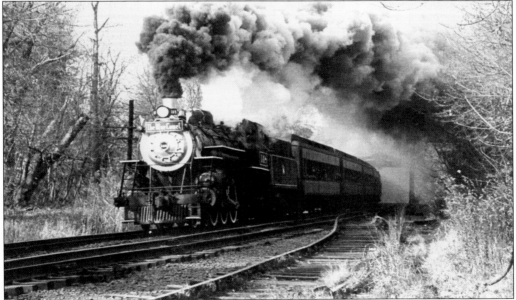

On December 6, 1975, the Mainline Steam Foundation sponsored a *Blue Comet* Nostalgia Special from Raritan to Bay Head behind ex-Florida East Coast Railway steam engine No. 148 hauling nine CNJ coaches. Rounding the curve into Middletown station, the train carried WNBC-TV *Tomorrow* show host Tom Snyder, filming a feature for his show. The side track (foreground) once served local distributors. (Courtesy Myron Silverman, Joel Rosenbaum collection.)

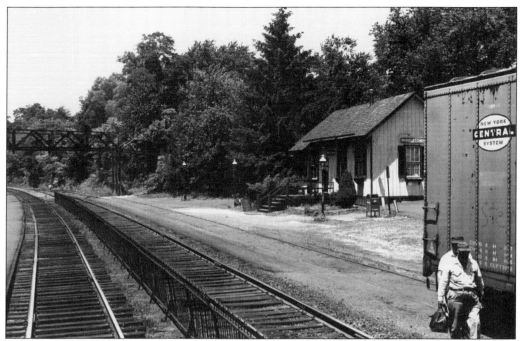

On a normal day, this one being in June 1970, the local drill crew casually walks to its next task as a New York Central (NYC) boxcar rests on the side track. Quaint Middletown station was built for the amount of business the township generated in the early 1900s. (Courtesy William J. Coxey.)

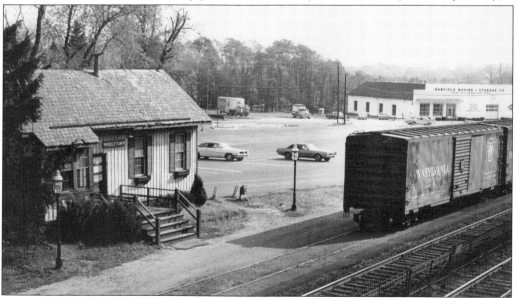

From an overhead bridge, the station and freight cars can be seen along with the Danfield Moving and Storage Company in the background. Few cars are parked in the small but adequate lot. It is the same day in June as above. Since a PRR boxcar is located where the NYC car was, the crew must be done with its drilling work here at Middletown. It is time for them to head for Red Bank. (Courtesy William J. Coxey.)

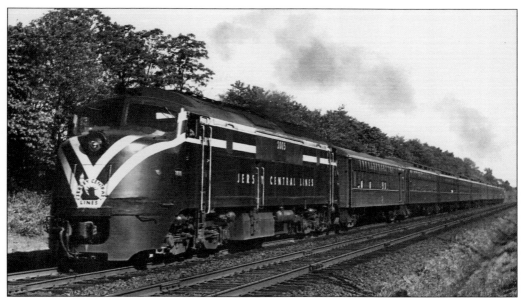

CNJ No. 2005 shows the brute strength of 2,000 horsepower and tractive effort. Easily handling the one combination baggage and passenger car (combine) and nine coaches trailing, this unit was one of only six of its kind built. Focusing on cost savings, the CNJ opted for a unit with cab controls at both ends to save turning costs. Its six wheel trucks have three axles each with the center axle serving as an idler, which made it light enough for some branch lines. (Courtesy Martin S. Zak.)

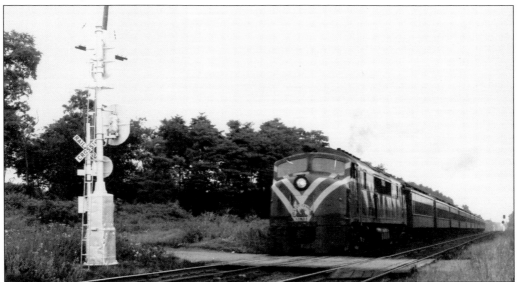

CNJ No. 2003 whisks its 10 coaches up the grade and must have a clear (maximum speed) signal on the signal mast with its back side to the photographer. The round disc at the bottom of the two signal heads allowed heavy freight trains to roll by slowly without coming to a complete stop when indicated. This avoided stalling and undesirable rail grinding getting restarted with heavy trains. All other trains must fully stop and then proceed slowly until the next signal provides the next authorized speed. (Courtesy CNJ.)

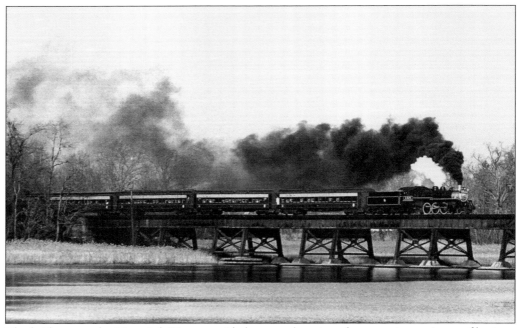

The bridge over the Navesink River provided seasonal settings for capturing trains on film into Red Bank. The same 1975 *Blue Comet* special pours smoke as it rolls over the steel two-track approach to the "Fountain City." On the rear is the original *Blue Comet* observation De Vico now numbered 1178. (Courtesy Myron Silverman, Joel Rosenbaum collection.)

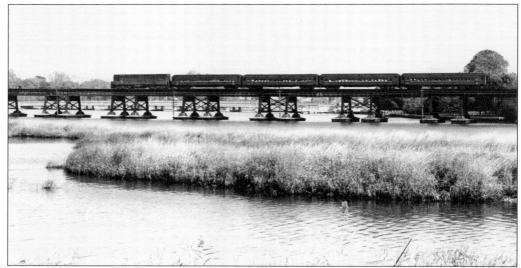

CNJ No. 5362 crosses the river headed for Jersey City in November 1968. Train numbers provide quick identification to railroad employees, and no two train numbers are the same each day. In this case (No. 5362), the 5 indicates Newark, the 3 Bay Head, and the 62 is the next sequence of numbers, it is followed by train No. 5364, No. 5366, for the most part. Even numbers mean the train is eastbound in railroad terms, or northward to customers. An odd number is westbound. There are number and letter code variations that do not conform as well. (Courtesy William J. Coxey.)

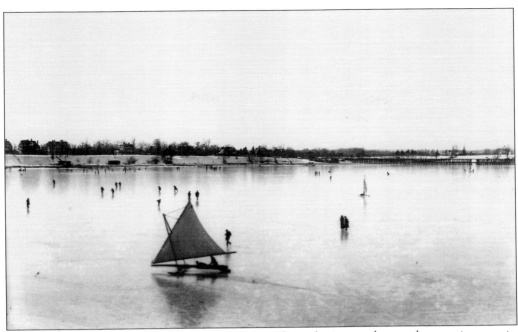

When the Shrewsbury River froze over, iceboat sailing, skating, and general recreation was in vogue. Always a beautiful setting in any season, residents enjoyed the natural entertainment provided by nature around the red banks of the Shrewsbury River. (Courtesy Tom Gallo.)

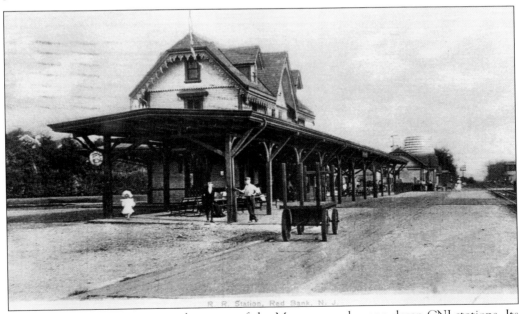

The Red Bank station was a carbon copy of the Matawan and over a dozen CNJ stations. Its Victorian style, gingerbread trim, and prominent status made it a natural center of transportation and social gatherings. Connecting rail branch lines, horse and carriages, stagecoaches, buses, and trolleys brought local travelers and wares to and from this hub of people, goods, mail, and gossip. Prominent people settled in such communities. (Courtesy Tom Gallo.)

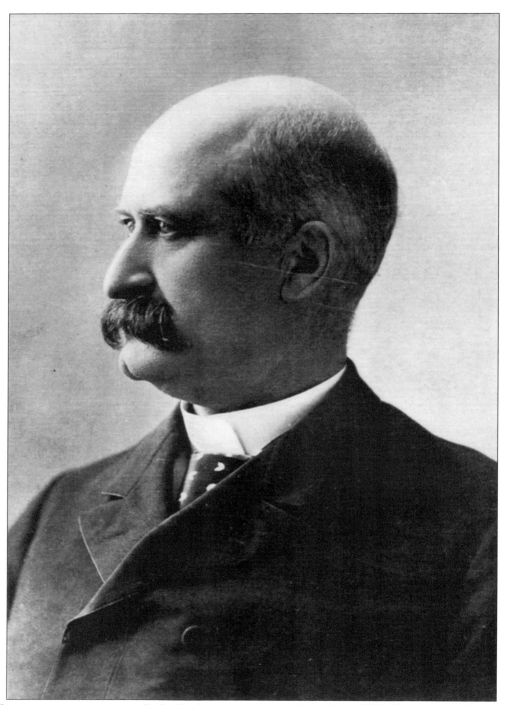

One important person was Rufus Bodgett, a superintendent of the NY&LB from 1884 through 1910. He also served as U.S. senator from 1887 to 1893 and mayor of Long Branch from 1893 through 1898 and again from 1903 to 1904. Such positions surely brought state-level attention to the county and its prosperity. (Courtesy Long Branch Public Library.)

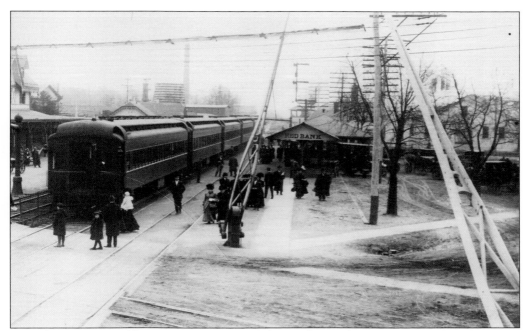

Long, heavy coats and hats are worn on a cold day on the westbound side of Red Bank station. A good view of typical wooden gates appears center and right. In the foreground is a trolley track crossing at 90 degrees with the NY&LB main here at Monmouth Street. (Courtesy Dorn's Classic Images.)

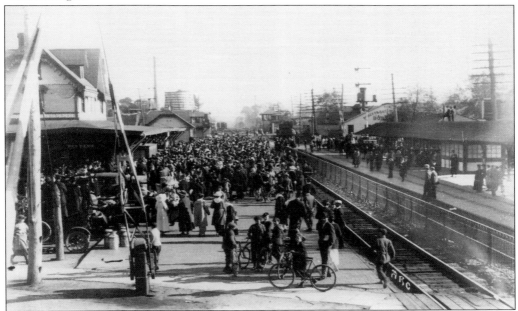

People gathered at stations for various reasons, even if they were not traveling. Maybe to pick up an arriving relative, or perhaps be intrigued by the power and impressive movement of visible locomotive moving parts, or maybe there was an important event? Something was about to happen. All these people could not be catching the train. (Courtesy Dorn's Classic Images.)

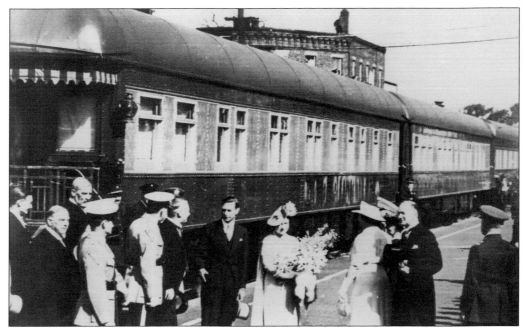

One reason to gather occurred on June 10, 1939, when the king and queen of England passed through Monmouth County deboarding their own train at Red Bank. The royal couple was met by New Jersey governor A. Harry Moore and Red Bank mayor Charles R. English. Mrs. English, the mayor's wife, presented the flowers. The royal couple greeted residents and stepped into a car headed for Fort Hancock on Sandy Hook to board the destroyer USS *Warrington* en route to the battery and the 1939 New York World's Fair. (Courtesy Tom Gallo.)

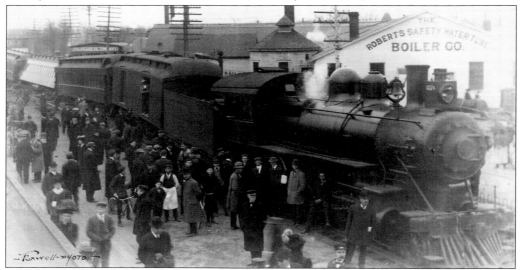

Another reason to gather was a train wreck. In this undated photograph, something went wrong when at least four of the trailing cars derailed along the station platform. The authors believe the train was backing up since the engine is still on the rails intact. Reverse moves were made at junctions to attach through cars from connecting trains, set out RPOs, and perform other business-related work. (Courtesy Joel Rosenbaum.)

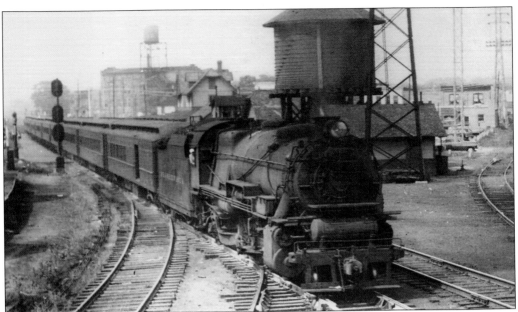

PRR No. 3635 has nine cars stopped heading south at Red Bank. Taken from the tower window this aerial view shows many long-gone landmarks such as the water tower, used to add water to the steam engines at midpoints. The track to the right is the former Raritan and Delaware Bay's main line to Port Monmouth, usurped when the NY&LB built its all-weather route to north Jersey points directly across the Hudson from the city of New York. (Courtesy Bill Burke.)

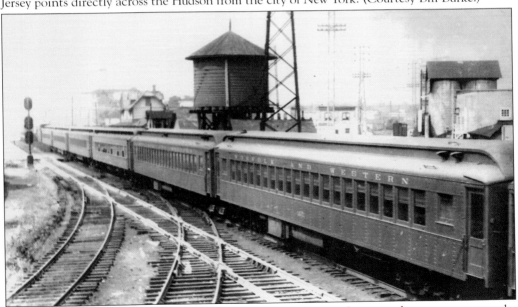

The PRR provided frequent scheduled services and plenty of extras when summer months compelled city dwellers to head for the beaches. The PRR added to the multitudes of equipment utilized on the NY&LB. Today Norfolk and Western Railroad coaches pass by Red Bank tower. Notice the "diamond" track crossing center bottom. Level track crossings (called diamonds) saved structural overpass construction costs. (Courtesy Bill Burke.)

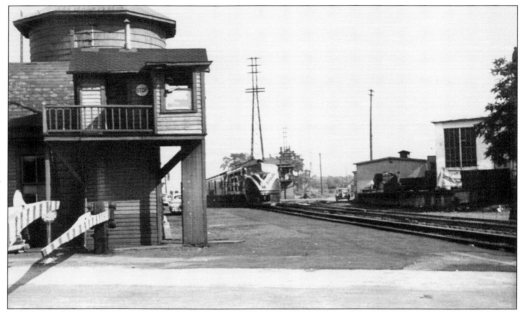

In front of the same water tower is a more elaborate watchmen shanty. It is elevated to provide a better advance view of approaching trains and vehicles. The stop sign is visible on the wall, as is the gateman in the open window. The gates are down, and CNJ double-ender No. 2000 has a safe passage into the station over the Oakland Street crossing. (Courtesy Howard B. Morris.)

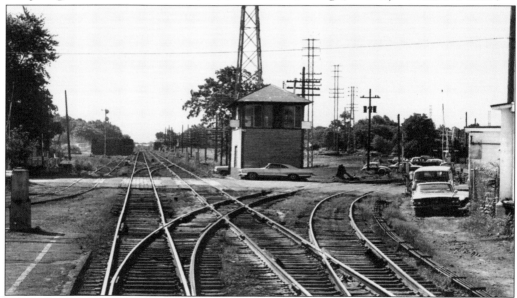

Taken from the hind end of a train, the crisscrossing track system, known as an interlocking, is easy to study. Switches were connected to the tower by rods on rollers with linkages and leverages to allow an employee on the second floor to "throw" switches and provide signal indications that engineers obeyed. Rods are visible to the right of the rightmost track. The diamond (center) allowed movements onto a track across another track, saving time and lengthy track arrangements. (Courtesy William J. Coxey.)

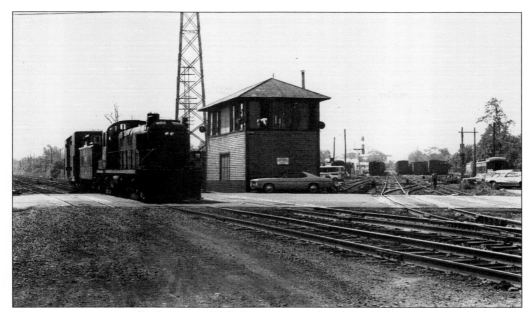

This tower was originally designated RG from a time when telegraph messages were the text messages of the day. Renamed BANK, it served for many years until Centralized Traffic Control featured remote dispatching from almost anywhere. CNJ RS3 No. 1550 has a caboose and an extra high boxcar being drilled. The conductor is on the lead of the engine on this day, May 21, 1976. (Courtesy Jim Boyle.)

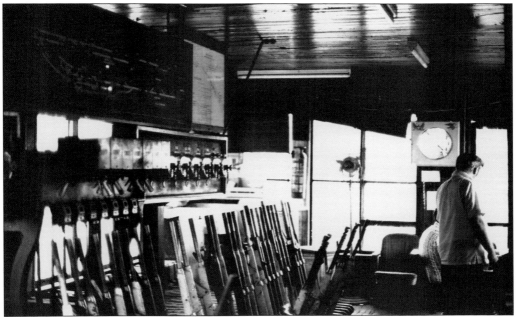

In July 1975, the interior array of levers looked almost the same as it did when new, except many unneeded tracks have been removed as business dwindled. Two employees discuss the plan and ensure coordination of the drill movements do not interfere with scheduled train service. (Courtesy William J. Coxey.)

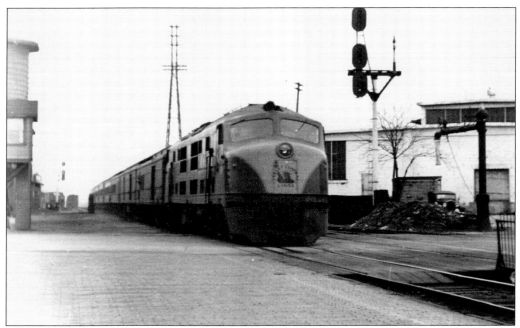

Center stage is CNJ No. 2000, the first of only six units ever built, wearing the original tangerine and orange scheme. The scheme featured a thin red line between the main colors as well as outlining the CNJ's Statue of Liberty herald. The statue's head is outlined with "Jersey Central Lines," an alternate name used by the CNJ. The signal mast at right protects movements into the yard near RG tower. (Courtesy CNJ.)

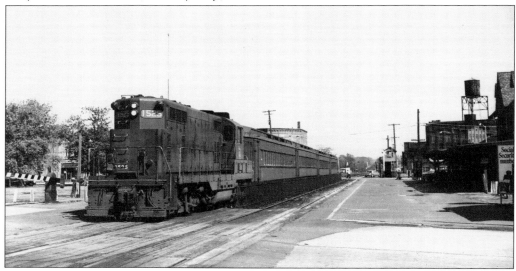

One of CNJ's best diesel electric locomotive investments was the EMD GP7, such as No. 1525 at Red Bank. With 1,500 horsepower, bidirectional controls, and the capability of being used in tandem with other engines, it was versatile. The flat front of the engine body was a modification to make room for an interior steam generator required to provide heat through a piping system to the coaches. The coaches dated from the 1920s, and a few served beyond 1976. (Courtesy Don Wood.)

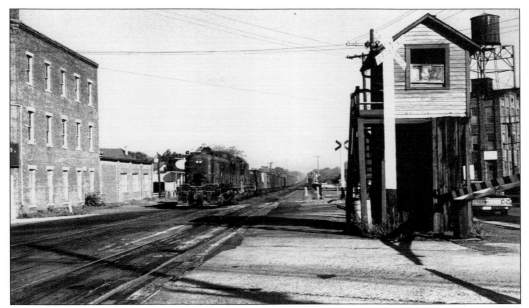

CNJ freight JR1 (Jersey City to Red Bank) operated daily except Sunday in 1969. It left Elizabethport at 5:30 a.m. and was due at Red Bank at 7:00 a.m., but record keepers noted it was usually late. It worked Matawan yard along the way and also Red Bank, its turning point. It was scheduled to leave as train RJ2 at 12:30 p.m. (same day) and work West Carteret, Tremley, and Elizabethport. The tall watchman shanty at Monmouth Street (right) is just one more elaboration on these important structures. (Courtesy Tom Gallo.)

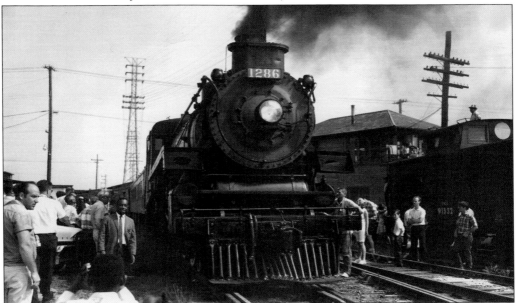

Bank tower's roof is just visible between the caboose and a visiting excursion train. Led by Canadian Pacific No. 1286, this train operated from Elizabethport to Bridgeton in southernmost New Jersey. Crowds gather around just as they did for the last 50 years, only this time, many were born long after steam was removed from Monmouth County's daily scenes. (Courtesy Don Wood.)

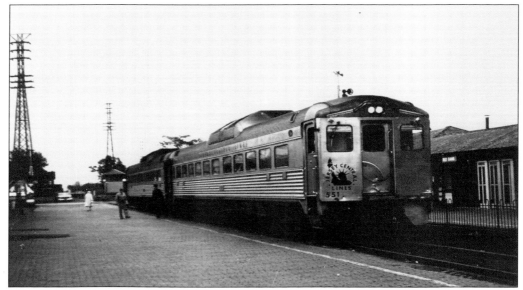

The RDCs were also a good investment for the CNJ. This stainless steel self-propelled diesel electric car could be operated from either end, used in multiples of two or as many as desired. The CNJ bought six units new and later four more secondhand. Unlike its other passenger coaches, these were air-conditioned and good for high-speed main lines or branch lines. They were well assigned to this run this day in the late 1960s when riders were few. (Courtesy Tom Gallo.)

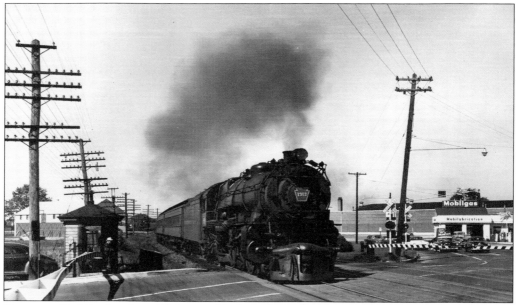

Departing Red Bank in June 1956 across Highway 35, PRR K4s No. 1361 rocks past the watchman leaning on the gate counterbalance outside his shanty, with his hat on of course. The wooden gates eventually were replaced by automatically activated gates, resulting in the retiring of the watchmen and shanties. The No. 1361 was preserved after retirement. The grade crossing light, an unusual single-target application here, had a sign on top reading "Entering Red Bank," and "Leaving Red Bank," as this PRR train is doing. (Courtesy Don Wood.)

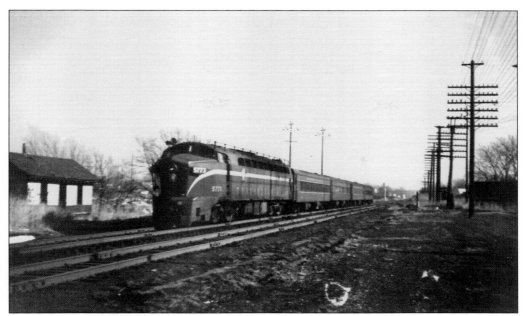

It is July 1966. PRR No. 5773, designated a Sharknose unit by builder Baldwin, handles a short string all alone. Heading north as it passes by Fort Monmouth, a military base located in Eatontown once served by the NY&LB and the CNJ Southern Division. (Courtesy Tom Gallo.)

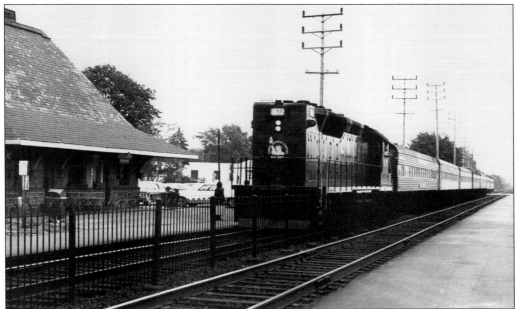

It is a hot August in 1972 at Little Silver train station. The hairpin-style iron fence separated the two main tracks so pedestrians did not randomly cross. CNJ GP40P No. 3672 has seven secondhand air-conditioned cars purchased from western United States railroads that were no longer providing interstate service. These replaced some of but not all of the 1920-era coaches. The GP40P is one of 13 purchased from EMD and would be the last new passenger power before the CNJ's demise in April 1976. (Courtesy William J. Coxey.)

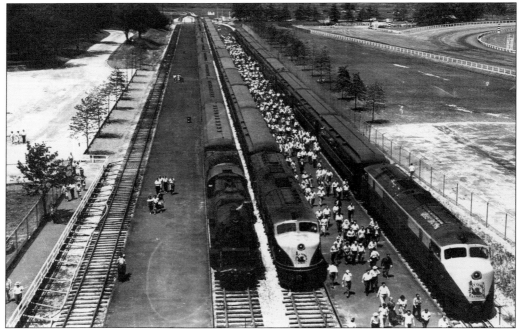

Long before state lotteries and casino gambling in the east, horse racing was a favorite pastime. Monmouth Park Racetrack offered daily doubles and some of the most famous thoroughbreds known. So lucrative was the market, the NY&LB built a four-track terminal spur direct to the grandstand. From the right, the CNJ trains have 9 and 13 cars respectively, and the PRR train has 12. The potential winners are all hurrying to the betting windows—they have to place a bet in the first races to win the daily double. (Courtesy James Raftery Turfotos, Joel Rosenbaum collection.)

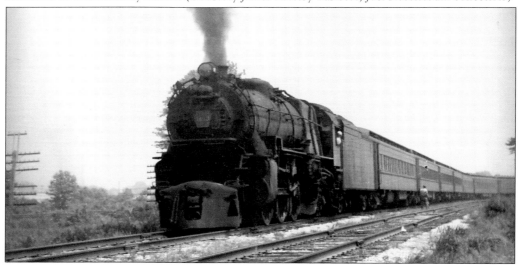

In July 1956, PRR K4s No. 1353 eases into the spur track at the racetrack. The engineer may have intentionally sent up a stream of smoke for show. The man walking along the train could be the yardmaster, an employee assigned to direct train movement on this intricate terminal system of tracks where no signals governed. A preserved 1950–1954 yardmaster logbook recorded an unbelievable amount of train movement and car numbers. (Courtesy Railroad Avenue Enterprises.)

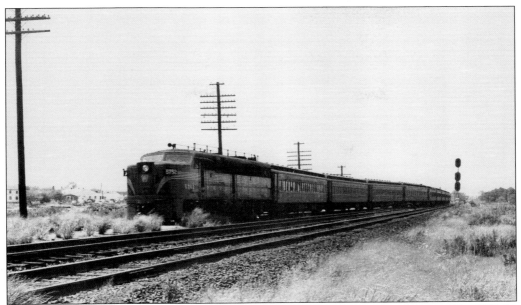

A 1950s extra service to Monmouth Park was headed by PRR PA-type diesel electric No. 5752. In the foreground are the two NY&LB main line tracks. The PA with its nine cars is switched onto the single-approach track that will lead to the grandstand. The PA has the antennae resembling a clothesline indicating it is radio equipped. The three-headed signal mast protected Oceanport Drawbridge, known as OD. It swung open to allow boaters access to an inland marina, making this a busy summer interlocking. (Courtesy Railroad Avenue Enterprises.)

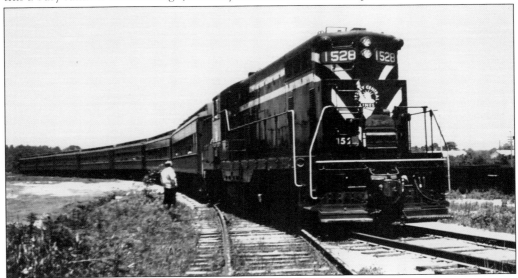

In the late 1960s, CNJ GP7 No. 1528 glides seven cars into the racetrack. Seven cars were enough, as gamblers now drove their own cars to "feed the horses," as it was known. The engineer is talking to the yardmaster, who instructs his movements once the train is empty of passengers. While the horses raced, trains had to be "turned," a process of getting the engine to the other end, then backing in so the train was poised to take the winners, and the losers, home. (Courtesy Tom Gallo.)

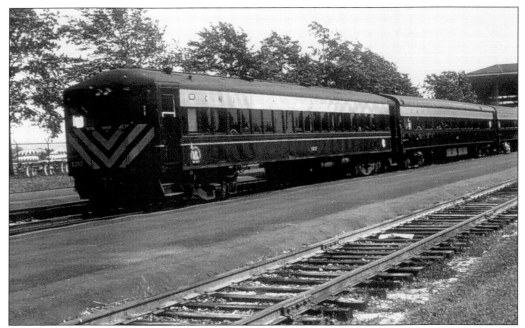

Turning trains slowly became a thing of the past as the CNJ built its own "cab control cars" from regular coaches. By installing controls in one end of a coach, adding a headlight, and more mechanical functions, an engineer could operate a locomotive on the other end of the train. Known as "push pull," this reduced tracks and maintenance, thus lowering operating costs. (Courtesy Marie and Norman Wright.)

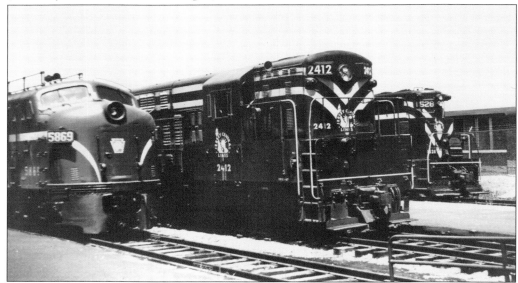

At the racetrack's bumper block, an end of track point, three locomotives seem to be edging their noses close to the finish line for this photo finish, a racing term for a close race. From left to right are PRR E8 No. 5869, CNJ Trainmaster No. 2412, and CNJ GP7 No. 1528. The turning process has not begun, indicating they just arrived. The No. 1528's luck ran out when it ran through an open drawbridge into the Newark Bay. (Courtesy Tom Gallo.)

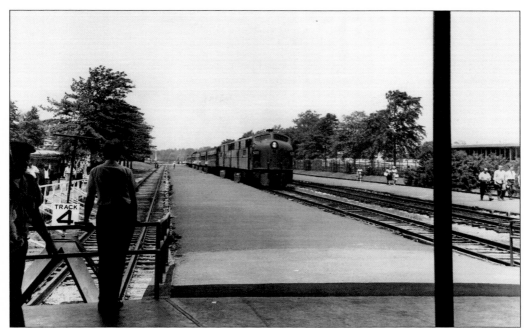

Times were lean. Two PRR E8s double-headed back to back, looking drab and worn and without their keystone symbols proudly displayed on their noses, bring in only six cars. Unlike the PA, handling a long string alone, dependability required pairing units so a breakdown along the way would not cause lateness for the first race. Buses unload on the left; they took away much of the railroads' racetrack business. (Courtesy James Raftery Turfotos, Joel Rosenbaum collection.)

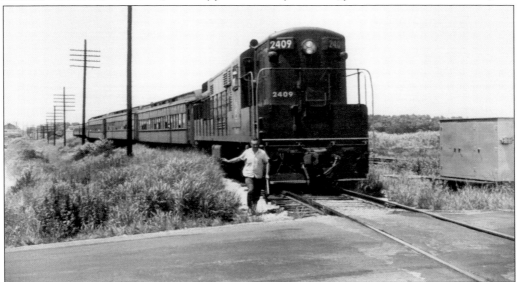

This July 1966 image captures CNJ Trainmaster No. 2409 and its eight coaches being "flagged" over (self-protected) the Port Au Peck Avenue grade crossing. A watchman was once assigned here in the busier times, along with the temporary yardmaster. Both are gone along with the business. Down to one or two racetrack trains, crews were on their own and had to provide their own protection to cross and turn the train. (Courtesy William B. Longo.)

Your Best Bet

Take it easy in a comfortable seat, study those racing sheets, visit the congenial Bar Car or enjoy a pleasant chat while you travel speedily; safely on Jersey Central

SPECIAL TRAINS
DIRECT TO GRANDSTAND
For Racing at
MONMOUTH PARK

JUNE 12 thru AUG. 8, 1956

☆

FIRST RACE 2.30 P.M.

☆

DAILY DOUBLE WINDOWS CLOSE 2.20 P.M.

STAKE RACES

JUNE 12, AUG. 6 and

every Saturday & Wednesday
(EXCEPT JUNE 13)

featuring

JULY 14
Monmouth Handicap
$100,000 added

JULY 28
The Monmouth Oaks
$50,000 added

AUG. 8
The Sapling
$50,000 added

⟦ **AIR-CONDITIONED BAR CAR** featuring tasty sandwiches and refreshing beverages on special trains as indicated below. ⟧

The horse race itself may have been fiercely competitive, but take a look at the aggressive marketing campaign run by the NY&LB's co-owners. The CNJ provided "Race Trains" from Raritan, Jersey City, and Broad Street Newark. It boasted air-conditioned bar cars with tasty snacks. Additionally it and the PRR stopped regular trains on the main line at Monmouth Park where customers could then walk into the grandstand. Stake races, handicaps, and daily doubles all created gambling hype. (Courtesy Tom Gallo.)

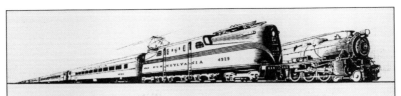

SPECIAL TRAINS
DIRECT TO
MONMOUTH PARK

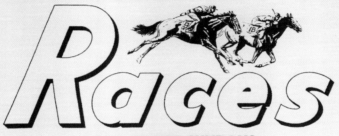

DAILY EXCEPT SUNDAYS
JUNE 16—AUGUST 8 incl.

The Convenient, Comfortable, Dependable Way

REFRESHMENT CAR—COACHES

Daylight Saving Time

	Mon. to Fri. incl. except Wed., July 4	Saturdays & Wednesday, July 4 only
Lv. NEW YORK, Penna. Sta.	12.25 P. M.	11.55 A.M.
Lv. NEWARK	12.39 P. M.	12.09 P. M.
Lv. ELIZABETH	12.47 P. M.	12.17 P. M.
Ar. RACE TRACK	1.40 P. M.	1.13 P. M.

Daily Double Closes 2.15 P.M. Post Time 2.30 P.M.
RETURN Immediately after last race

ROUND-TRIP COACH FARES
Including Federal Tax

FROM NEW YORK **$4.05**

FROM NEWARK **$3.05** FROM ELIZABETH **$2.65**

The PRR flyer shows speeding electric and steam trains across the top, letting passengers know they will get there on time and in comfort. They provided a refreshment car. PRR trains came from New York City, Newark, and for a time, Philadelphia. The daily double closed at 2:25 p.m.; post time was at 2:30 p.m. Trains usually left 15 minutes after the last race. Trains operated on a schedule to the track but ran as "extras" returning due to the uncertainty of the last race's finish time. (Courtesy Tom Gallo.)

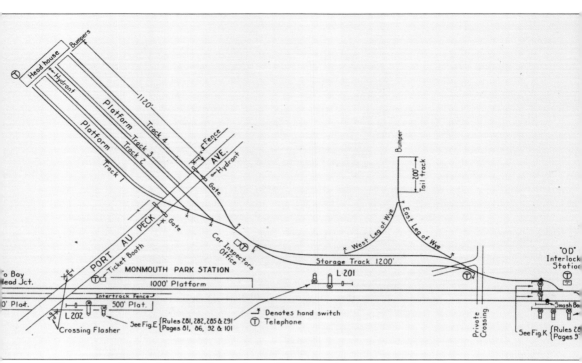

This General Order No. 19, effective June 19, 1947, under superintendent Mike Strollo's authority, describes a layout of the new track system at Monmouth Park and Oceanport Drawbridge Interlocking. A trainmaster, a management employee who oversees daily train operations, is assigned to serve as the yardmaster. The wye track facilitated turning (similar to a K turn for vehicles) single-cab steam and diesels, such as the K4s, Shark, PA, and E8 units that were not paired back to back. In the yardmaster's logbook on July 4, 1951, he wrote that the PRR operated three special K4s-powered trains to the grandstand, including one from Philadelphia. Two trains had 12 cars each, and one had 4. The three trains carried a total of 1,823 passengers. The CNJ ran two diesel-powered special trains—one from Jersey City and one from Broad Street Newark. Those two trains carried a total of 1,630 passengers. (Courtesy Tom Gallo.)

42

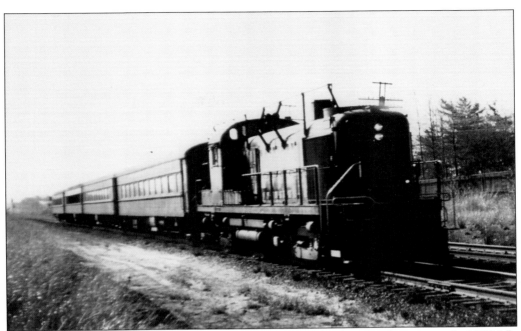

Unique motive power certainly attracted photographers and railroad enthusiasts on the NY&LB. Here a PRR American Locomotive Company (ALCO), with its signature PRR antennae serving as a boast that it is now radio equipped, pulls four coaches along the main line. There is a good chance this engine is being used due to a bridge strike and long-term damage up north. More about that later. (Courtesy William B. Longo.)

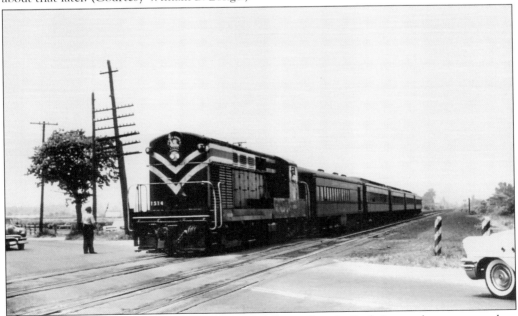

A bright and shiny CNJ Baby Trainmaster is crossed over Port Au Peck Avenue by a crewmember. It has stopped to let gamblers off at the seasonal Monmouth Park main line station. No. 1514 will easily roll the combine and four coaches to Bay Head. (Courtesy Tom Gallo.)

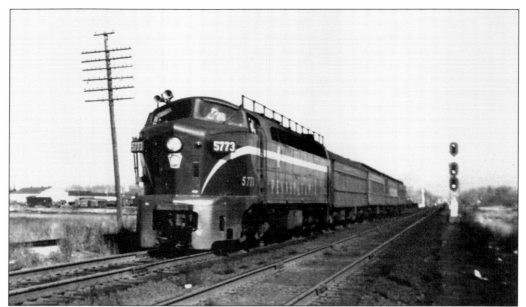

PRR Sharknose No. 5773 with four just crossed Oceanport Drawbridge and stays on the main line, passing the spur into the racetrack. It is surprisingly clean and bright in this late-1960s view. The signal on the mast displays a "clear" signal, which is a green light over red over red. Color combinations dictated various speeds for safe movement. (Courtesy Tom Gallo.)

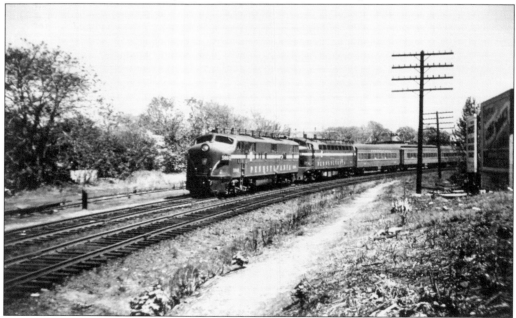

This double-headed PRR train is led by E8 No. 5869 followed by PRR Shark No. 5774. What is unusual about this double-headed lash up is both locomotives are facing the same way. It is referred to as "elephant style," nicknamed for the way circus elephants walk in a train-type line, trunk to tail facing the same way. Since the yard crew did not place them back to back, it is not a racetrack train. (Courtesy William B. Longo.)

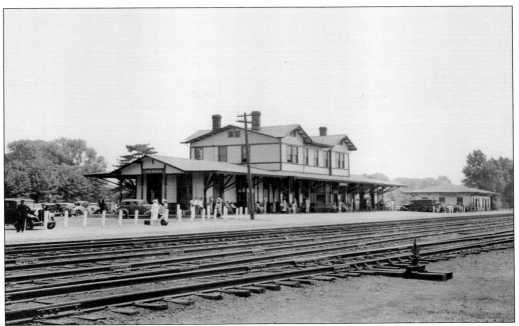

July 24, 1937, at Long Branch station was a quiet day despite a good number of waiting travelers and relatives receiving guests off the train. The station, a large wooden-framed, two-story structure, was in a prominent city of tourism and charm and a key player in the development of the county. Both the CNJ and PRR knew the importance of serving this city with frequent service to just about anywhere in any direction. (Courtesy George E. Votava.)

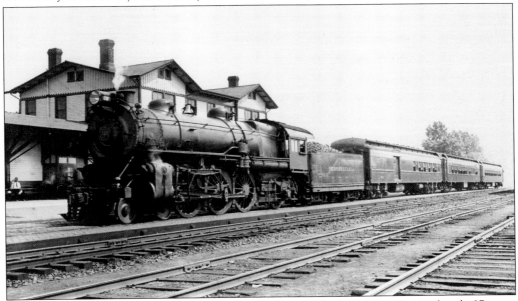

Same day and along comes PRR K2s No. 732. Built in 1910, the locomotive is already 27 years old. Steam could hold its own if well maintained. This train is No. 810, which began its trek to Long Branch in Philadelphia, passing through Sea Girt at SG tower south of here. (Courtesy George E. Votava.)

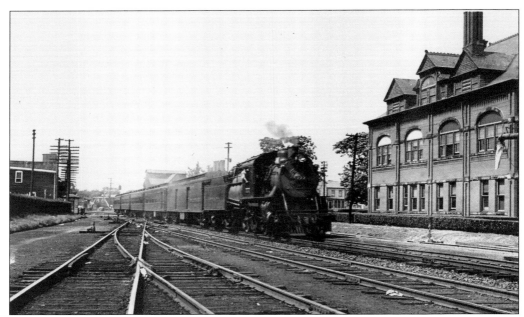

It is the same day again as southbound CNJ train No. 3317 (Jersey City to Bay Head) glides into Long Branch past the NY&LB headquarters building at right. Gamblers would have delighted if this engine, No. 777, had been assigned to the racetrack train. The very hot cab forced employees to lean out, as is seen here. The wide firebox on the engine created a humped look, fostering the nickname "Camelback." Using animals as nicknames may seem odd, however, consider the automobiles named Mustang, Bronco, and Jaguar. (Courtesy George E. Votava.)

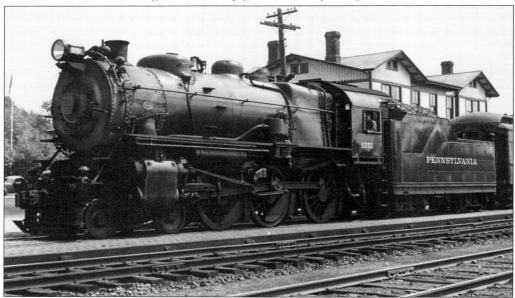

A busy July 24, 1937, captures PRR No. 5701, a G5s built by the PRR itself before outsourcing became cheaper for all railroads. One of the features noted by the photographer claims these G5s models kept good time, making quick starts and stops where stations were close together, as was true for many NY&LB stations in the early 1900s. (Courtesy George E. Votava.)

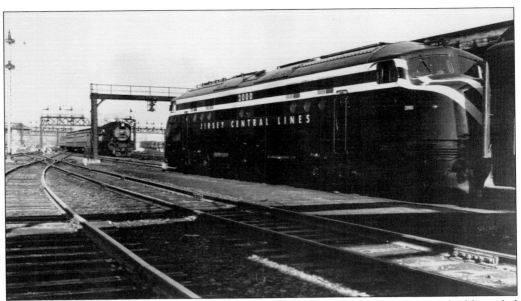

Getting into the diesel purchase mode, in 1948, the CNJ let its riders know more double-ended diesels were on order. Only six double-ended units were made by Baldwin, and all were for CNJ. The double-enders were geared for passenger service only. The units were displayed around the entire CNJ system. This image shows No. 2000 clean as a whistle in Jersey City ready to depart. (Courtesy Tom Gallo.)

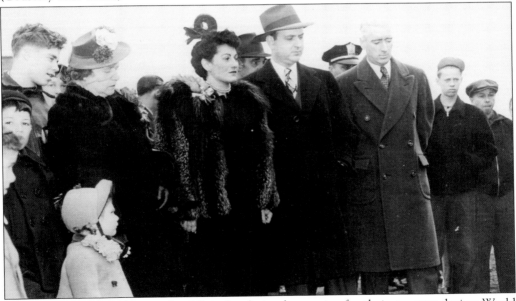

CNJ honored its employees who fell in battle in the service for their country during World War II by christening new diesel locomotives after them. On March 29, 1947, such a ceremony was held at Long Branch in honor of employee Elmer F. Shinn. His wife, Henrietta, is center along with his three-year-old daughter, Alice Roberta Shinn, at the engine dedication. CNJ double-ender No. 2002 had a plaque affixed honoring Elmer below its cab window, as did seven other new diesels. (Courtesy CNJ Coupler.)

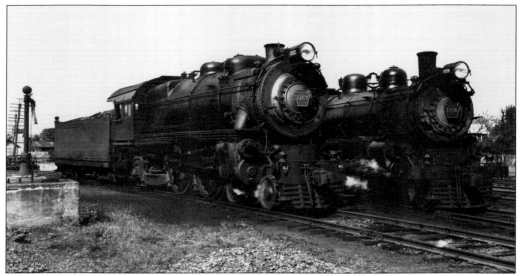

Once steam engines pulling PRR trains from Philadelphia and Camden set their trains into the yard for servicing, the locomotives then headed for the turntable just east of the station. A turntable was another means to turn a single-faced unit around, in a small circle without land-consuming wye tracks. Refilled with coal and water from the spout to the left, these two units, No. 1163, an E6s, and No. 6536, an E5s, await their next assignments on October 18, 1936. In the 1950s, one such assignment was protecting Prudential excursion trains. (Courtesy George E. Votava.)

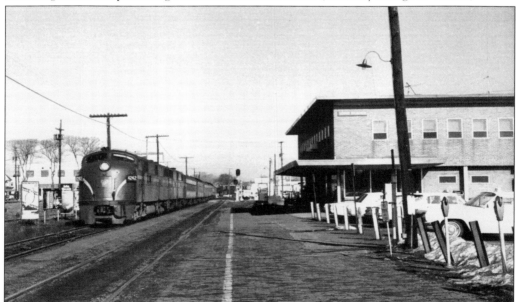

A pair of E8s led by No. 4242, sporting the PRR's famous keystone herald and stripes, coasts into Long Branch station in the late 1960s. This station is the 1955 steel and brick second station built here with a second floor serving as a dispatch center and management offices for the NY&LB. It replaced the headquarters and former wooden station. CNJ veteran employee George Lester Whitfield spent many hours here until the building was razed. Small snow piles line the front of the cars parked by the meters. (Courtesy William B. Longo.)

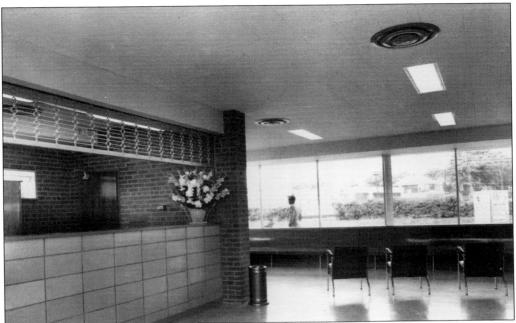

The inside of the new station (August 1955) features attractive stonework, acoustical ceiling tiles, tile floors, and a large window through which to see trains arriving. Even fresh flowers are on the counter. A soldier in uniform is visible through the window today, possibly heading for nearby Fort Monmouth or about to depart. (Courtesy CNJ.)

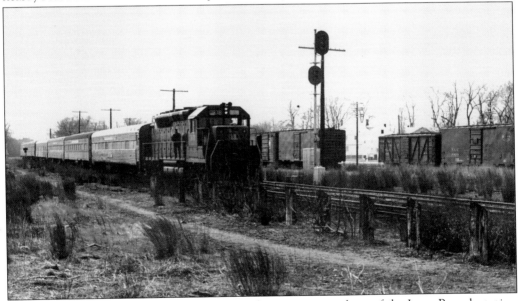

CNJ Train No. 5362 with GP40P No. 3678 and six cars is just short of the Long Branch station with a crew member walking along the engine's deck. To the right are revenue freight cars that a local drill will pick up when appropriate. The car with the outside bracing is pre–World War II vintage belonging to the Wellsville, Addison and Galeton Railroad. Everything was used until it did not meet standards or became too expensive to maintain. (Courtesy William J. Coxey.)

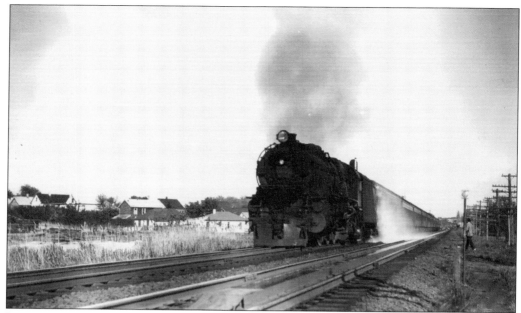

Just east of Long Branch is Branchport. The NY&LB and the CNJ's Eatontown to East Long Branch rail lines crossed each other on a diamond nearby. Another railroad feature in this section was track pans built between the rails whereby steam engines could scoop up water without stopping. Such maneuvers allowed railroads to advertise the quicker running times. PRR No. 3847 splashes some water about but not enough to wash the 10 trailing cars. (Courtesy Charles Brown, Joel Rosenbaum collection.)

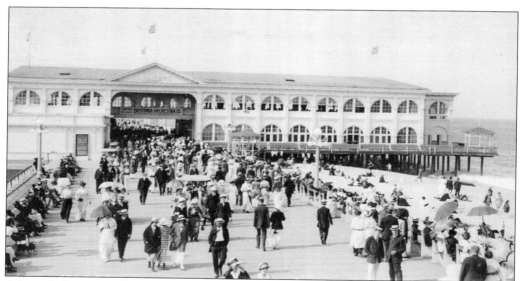

Asbury Park attracted people with its grand homes, gardens, and the famous boardwalk, a Jersey Shore tourist attraction that gave the railroads plenty of good business. Straw hats and bonnets, wicker wheel chairs for those who could afford to be squired around, and sandy beaches with blue seas and white surf were in vogue. The Bostonia Orchestra is playing tonight in the arcade in the background, but for now, all enjoy a sunny stroll along the boardwalk. (Courtesy Tom Gallo.)

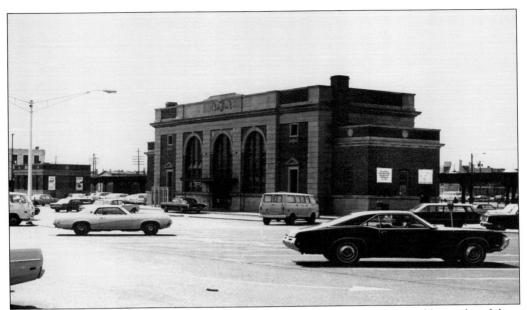

In March 1970, the majestic Asbury Park station with its cathedral ceiling and large chandeliers stands, as do the pyramids, marking a time when the railroads rewarded cities from where they would profit with a befitting tribute. No other station received this much grandeur in Monmouth County. There was a time when hundreds of stagecoaches and wagons lined up to carry visitors from trains to the boardwalk attractions and the beach. (Courtesy William J. Coxey.)

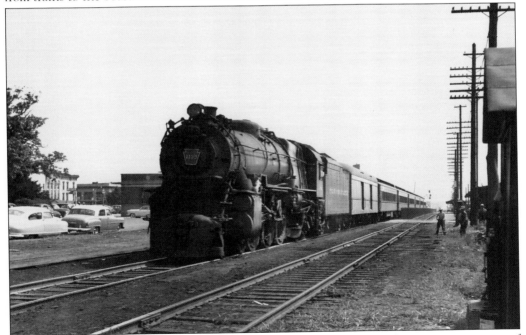

PRR K4s No. 1139 awaits the conductor's signal that all are aboard and it is time to get out of town eastward. The corner of the station peeks to the left, while track workers stand back to the right until the train passes and work can resume safely. (Courtesy Don Wood.)

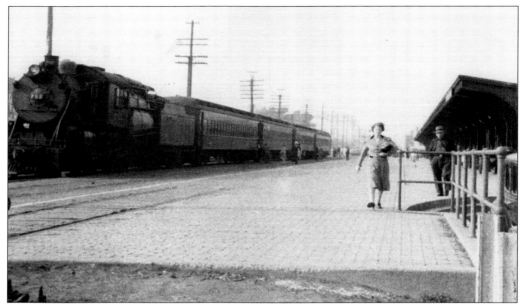

Camelback No. 782 with four cars picks up a few people and drops off less. This CNJ train is headed west (south) to Bay Head. The woman in the foreground must have ran as others are still getting off the train in the distance. Maybe she wanted to be first on the beach. (Courtesy Howard B. Morris.)

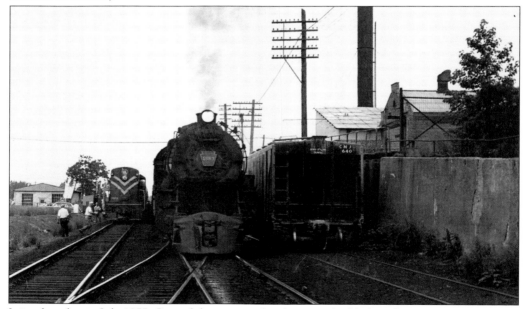

It is a hot day in July 1955. One of these trains has become disabled, and a passenger transfer is underway. Since the photographer did not make a note, it is unfair of the authors to say which railroad had the breakdown. The CNJ train is on the correct track for the direction traveled and a rescue train would approach on the opposing track. Best guess is the newer diesel broke down and an old steam engine saved the day. The customers do not care; they just want to get home. (Courtesy North Jersey Electric Railway Historical Society.)

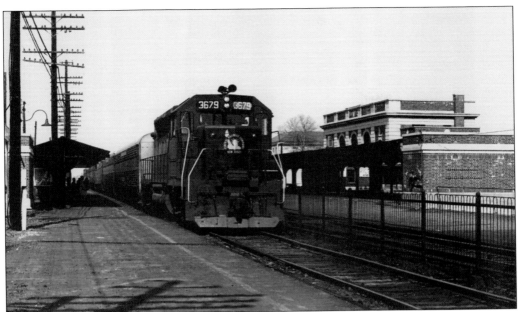

Showing signs of age in 1970, the station has patches in its brick exterior, signs of water damage and deferred maintenance. CNJ No. 3679 with six has not yet stopped as the waiting public is standing back. The brick paved platform on this side has a coat of macadam applied in an effort to provide an easier walking surface. A standard CNJ candy-cane-style lamp is visible from the telephone pole at left. The numerous wires on the poles are from a time when railroads had their own telephone and telegraph systems. (Courtesy William J. Coxey.)

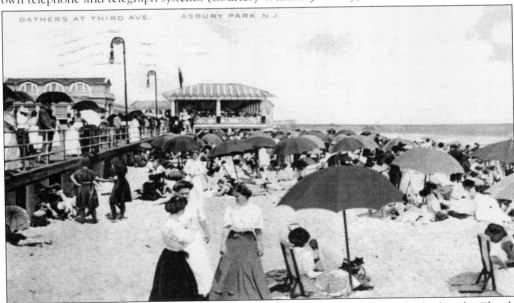

Shown is another visit to the Asbury Park waterfront, and this time it is on the beach. Clearly swimwear covered much more of the body in this 1911 view than today. The umbrella was a necessity to keep the pounding sun off. The pavilion in the background is crowded with many catching a breeze from the Atlantic Ocean. (Courtesy Tom Gallo.)

53

BABY PARADE

AT

ASBURY PARK

WEDNESDAY, AUG. 31st, 1921

SPECIAL EXCURSION

Each railroad advertised for and operated extra trains for any special event. Come see the world's fair in New York (1939) or take a trip to the coalfields of Pennsylvania, ladies' shopping day on Wednesday (in New York), and excursions just anywhere. This CNJ advertisement for the baby parade shows that people would travel distances to win high-recognition events. Baby parades were common in local towns, but this is the big one! (Courtesy Tom Gallo.)

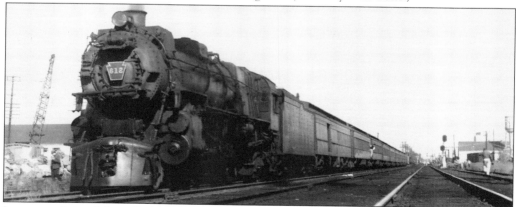

Just west of the Asbury Park station was Neptune Yard. It hosted numerous tracks for holding special excursion trains and local freight cars. This October 20, 1957, image has PRR No. 612 and 10 cars backed into a side track clear of the two main tracks. The Prudential Insurance Company, Newark, operated annual excursions for employees, with the CNJ and PRR alternating years handling the trains. (Courtesy Railroad Avenue Enterprises.)

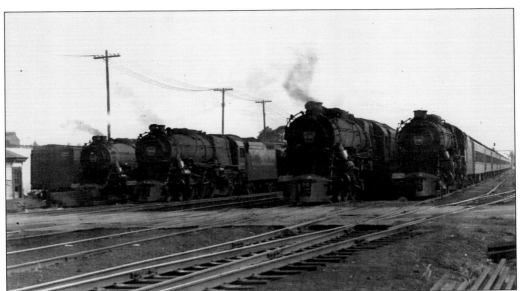

Four PRR Prudential excursion trains are stored in the yard in 1949. On Friday, July 20, 1951, the Prudential excursion used five PRR trains with a total of 60 PRR P70-type coaches. The five sections were to pass Perth Amboy tower WC at 7:05, 7:45, 8:15, 8:45, and 9:20 in the morning, unload at the station, yard the train, uncouple, and take locomotives only to Bay Head for turning and servicing. Each returned, coupling up to a string of P70s, and then began operating east at 4:30 p.m. (Courtesy North Jersey Electric Railway Historical Society.)

By 1970, there were no company excursions, baby parades, or trains other than a few steam-engine runs. The Neptune yard was devoid of half its tracks, with just a few boxcar deliveries for local consignees. A building is being demolished as time takes it toll. Boardwalks along Jersey's extreme southern shore are now easily reached via the Garden State Parkway. (Courtesy William J. Coxey.)

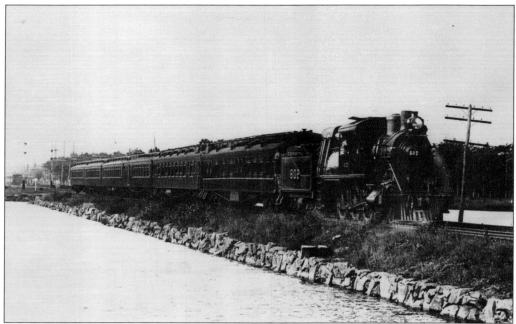

CNJ Camelback No. 602, with six wooden-framed cars, rolls across the fill at Deal Lake in North Asbury Park. The body of water provided recreational pleasure and an artistic foreground for many. The first two cars are parlor cars, a first-class form of rail travel in its day. (Courtesy George E. Votava.)

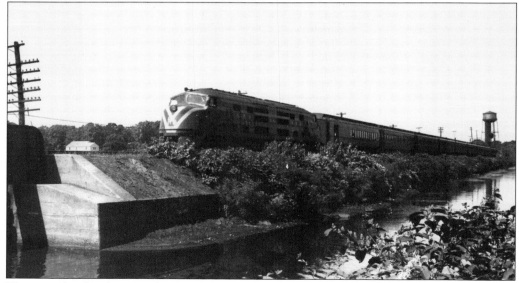

The water level is down in the causeway. CNJ No. 2000, a combine, and eight coaches have the back of the train in Deal Lake and the front in North Asbury Park. The door to the combine is open, a self-created form of air-conditioning inside the compartment but a rule violation as well. Combines carried U.S. mail and newspapers while still providing some seating for passengers. Otherwise, a full baggage car would be wasted as well as the fuel to haul it around. (Courtesy CNJ.)

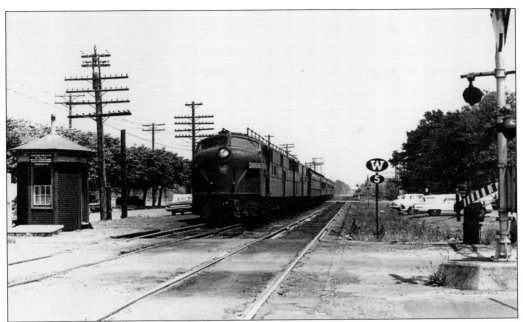

Two E8s haul four coaches through North Asbury Park. The shanty sign reads, "Crossing Protected by Gates Weekdays 5:25 a.m. to 9:45 p.m. Sundays 8:00 a.m. to 12:00 a.m." To the right are a wooden gate and electric flasher, which substituted for the gates when no watchman was on duty. The W over the 5 is a sign alerting engineers they are approaching five grade crossings and to sound the whistle. (Courtesy Railroad Avenue Enterprises, photograph by Bob Pennisi.)

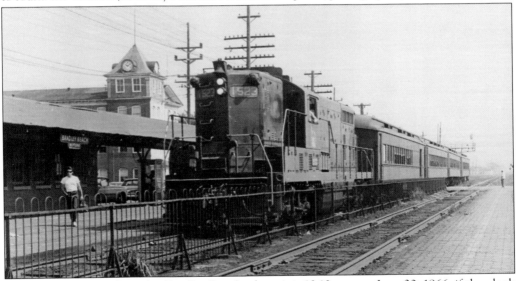

GP7 No. 1523 is southward at Bradley Beach where it is 10:10 a.m. on June 30, 1966, if the clock is correct. The date is correct. The brick paved platform is holding up. The GP7s were used for both freight and passenger service and could be coupled up in tandem with other units for heavier freight assignments and long-haul passenger runs between Pennsylvania and Jersey City. The GP stood for General Purpose, a well-named marketing moniker by EMD. Many railroads bought these units. (Courtesy Railroad Avenue Enterprises, photograph by Bob Pennisi.)

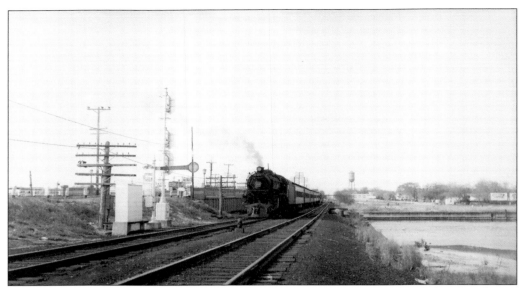

It is June 1955 at the stop signal for Shark River Drawbridge. The three-headed mast indicates three red lights meaning stop. The round disc is a smash board intended to hit the engineer's window should he not stop. It will not stop the train but it will make him focus. Author Tom Gallo and his mother, Joan, worked across the street in a restaurant, the Fisherman, allowing him time to stand on the roadway bridge and watch train and drawbridge operations. (Courtesy North Jersey Electric Railway Historical Society.)

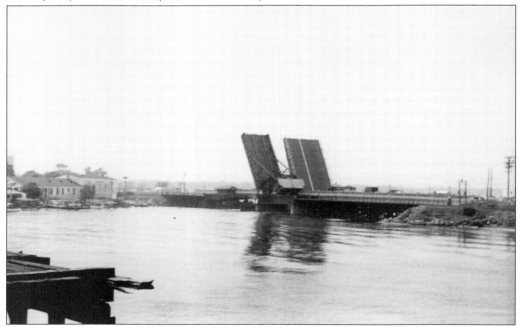

Located in Belmar, these two side-by-side railroad and State Highway No. 35 drawbridges open simultaneously to allow pleasure and commercial marine traffic through. Personal boats and day-fishing trips required very frequent raising and lowering, sometimes even in winter. Cars wait for trains at crossings, and trains wait for maritime traffic. (Courtesy Howard B. Morris.)

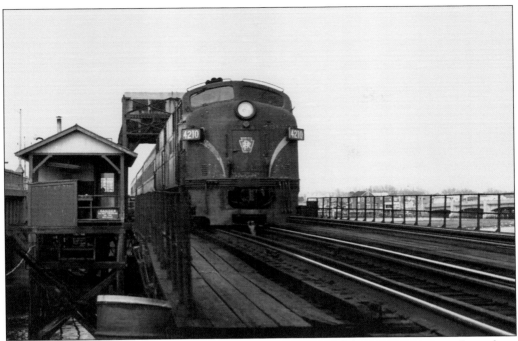

Near the bridge tender's cabin, E8 No. 4210 shows signs of flaking on its stripes. It is alone pulling four coaches this March day of 1970. (Courtesy William J. Coxey.)

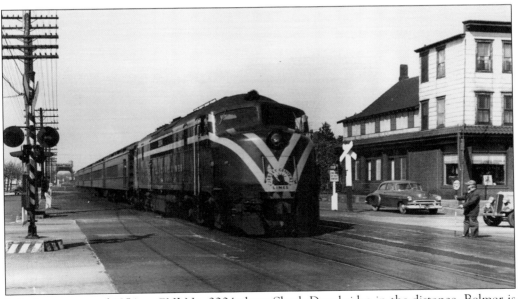

It is the summer of 1954 as CNJ No. 2004 clears Shark Drawbridge in the distance. Belmar is an attractive town with a heavy accent on boating, beaches, shops, and quaint vistas. There are automatic flashing warning lights seen at left. Even though there are no longer wooden gates, the watchman is in place with his stop sign. (Courtesy Don Wood.)

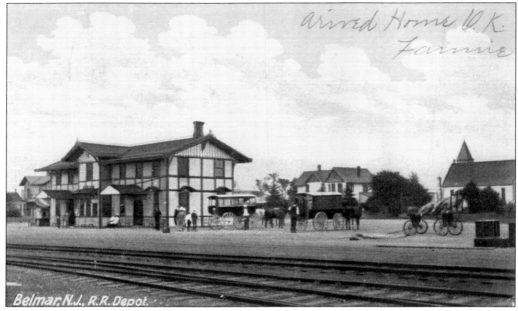

The Belmar depot of yesteryear was an ornate two-story structure. On this 1906 postcard is inscribed, "Arrived home ok. Fannie," written to her friend in Trenton. Of interest, the postal stamps for both Trenton and Belmar are August 26, 1906, with the card leaving Belmar at 6:00 a.m. and arriving in Trenton at noon. Mail train or stagecoach, either way, that was fast service. (Courtesy Tom Gallo.)

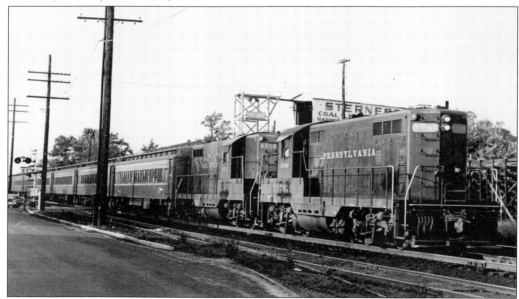

The PRR bought GPs as well, utilizing here No. 8509 and No. 8510 double-headed westbound at Belmar on July 30, 1956. Just over the locomotive is a sign advertising coal for sale. The PRR ended its use of coal-fired steam engines on the NY&LB in November 1957. The CNJ was completely dieselized by 1954. Home owner's also began converting to oil and natural gas heat. (Courtesy North Jersey Electric Railway Historical Society.)

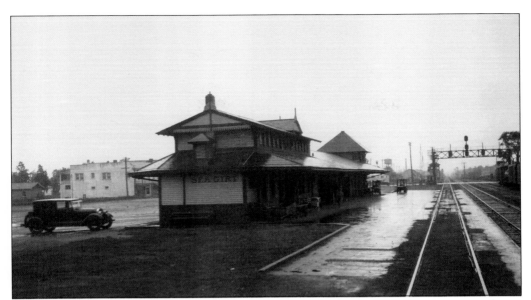

Sea Girt has its own interesting railroad history, reached first by the PRR from its western Jersey rail lines from Trenton. As the NY&LB stretched southward, it shared trackage rights over this short section of PRR real estate. Two main line tracks to the left and two side tracks at right were controlled by SG tower in the distance and the overhead block signals. When signal masts did not fit between tracks, overhead structures where used for signals, which had to be to the right of the track they served. (Courtesy Francis Palmer.)

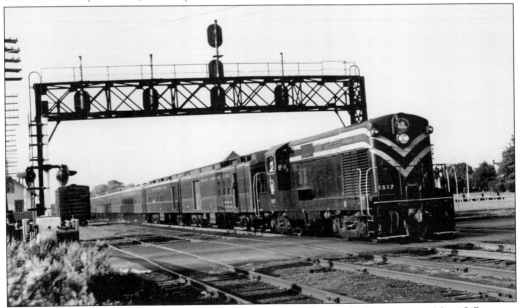

A better view of the signal structure from the opposite side as Baby Trainmaster No. 1517 proves its versatility and strength in July 1954 with an RPO, combine, and at least four coaches headed for Bay Head. The mail clerk inside the RPO has thrown off mail bags where no stop was scheduled or offloaded bags onto wagons where stops were made. Going north, the collecting and onboard sorting process begins all over. (Courtesy G. Jack Raymus.)

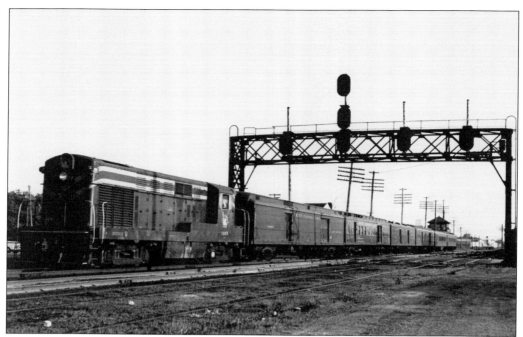

On the same day, northbound CNJ No. 1509, one of 18 purchased by CNJ, leads a full mail train to Jersey City. Of the three U.S. mail cars, some may be empty and will be exchanged with a loaded car. The RPO, second car, will see sorting and crane collecting activity on this run. The combine and last coach play a role, one of which served as a "rider" car for the crew who cannot get comfortable in a mail car. (Courtesy G. Jack Raymus.)

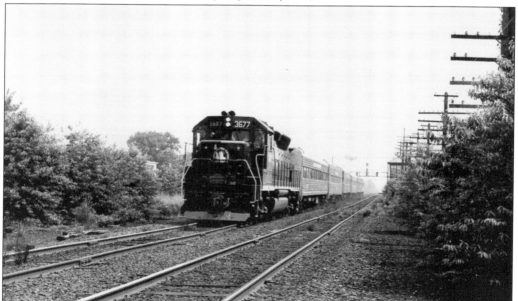

Train No. 5305 (Bay Head to Newark) has six refurbished secondhand cars and a CNJ GP40P leading short hood out. SG tower is boarded up and no longer used, as is the PRR connection. (Courtesy William J. Coxey.)

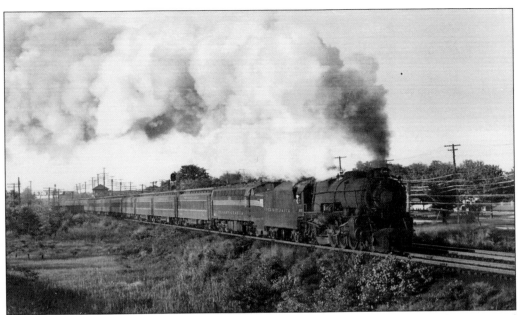

In the period between steam phaseout and diesel purchases, unusual double-heading occurred occasionally. PRR K4s No. 830 leads a Baldwin BP20 Sharknose diesel and 14 coaches through Sea Girt. While both could have handled the train, they would not be able to maintain the frequent stop-and-go schedule of this lengthy, heavy commuter train. (Courtesy North Jersey Electric Railway Historical Society.)

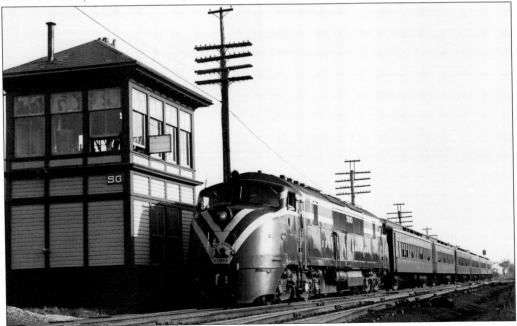

This is a classy image of SG tower while it was still open for business. Handsome and shiny double-ender No. 2003 sprints six coaches with ease into the Sea Girt station. The tower is in very good condition in this 1954 view. (Courtesy G. Jack Raymus.)

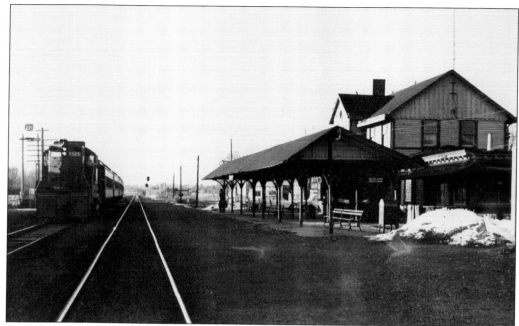

Manasquan station was a wooden building featuring a round porthole-style window. This station building once stood at Spring Lake as its station. Approaching eastward is CNJ GP7 No. 1525 without CNJ's yellow "toothpaste" stripes seen in earlier images. Deep sea green and a few Statue of Liberty heralds kept painting costs down. The CNJ eventually painted diesels blue and yellow amid rumors of a takeover by the Baltimore and Ohio Railroad, which used those colors. (Courtesy Joel Rosenbaum.)

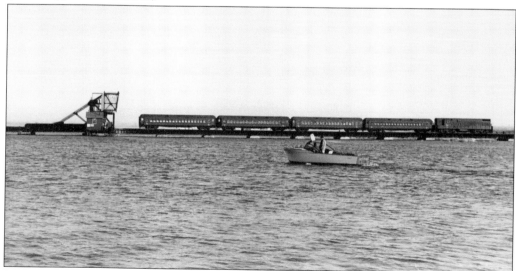

Seen is yet another drawbridge for a total of five moveable bridges on the NY&LB railroad. The CNJ had a few more en route northward. The PRR elevated tracks and eliminated such nuisances, having better financing and routing options. CNJ train No. 5357 rolls its train out of Brielle, Monmouth County, and into Point Pleasant in Ocean County. The rolling draw span is just behind the train. (Courtesy William J. Coxey.)

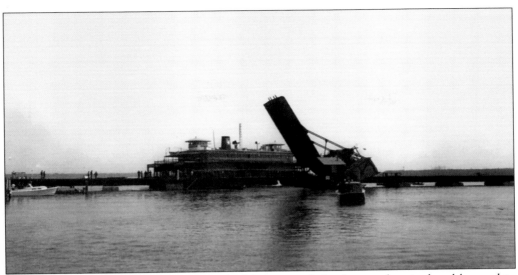

Known as Brielle, this drawbridge over the Manasquan Inlet frequently raised and lowered to accommodate both marine and rail traffic. In this particular opening, the CNJ's former ferryboat *Cranford* is being squeezed through to be moored permanently to become a floating restaurant. (Courtesy Howard B. Morris.)

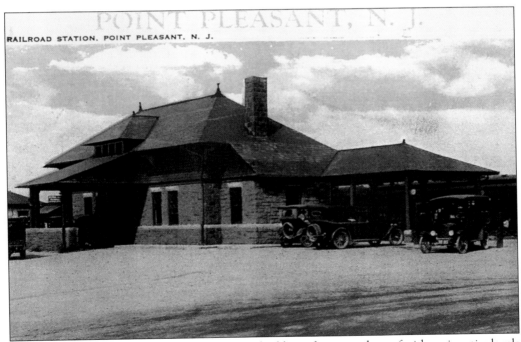

This Point Pleasant station was a very attractive building of stone and a roof with various tier levels and eaves. It was the second station built here, replacing the original wood-frame depot in 1903. Point Pleasant served as the end of the NY&LB until 1882, when the line extended to Bay Head Junction. Point Pleasant was renamed Point Pleasant Beach in 1957. (Courtesy Tom Gallo.)

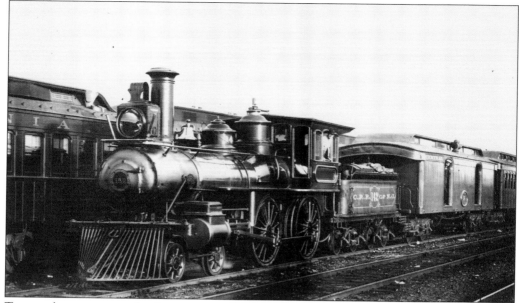

Two employees peer out for the camera as CNJ steam engine No. 142 is shiny and clean. Classed by wheel arrangements front to back, this is a 4-4-0, two axles with small wheels, two driving wheels, and no wheel under the cab. Larger units did have wheels under the cab. This is Point Pleasant serving as the line's end. (Courtesy William C. Schoettle.)

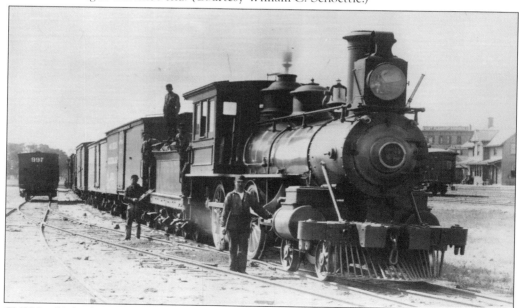

CNJ No. 72, built in 1866 by the Taunton Locomotive Works and scrapped by the CNJ in 1903, has a poised crew and a string of freight cars ready to go east as a local drill. They wait for a clear opening as scheduled trains with passengers have superiority by accepted rules and timetable authority. Pocket watches were a critical tool to be compared and frequently checked against the printed employee timetables and special tower orders to get off the main line on time. (Courtesy William L. Schoettle.)

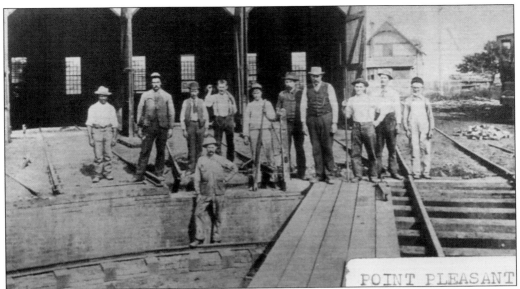

The turntable and roundhouse at Point Pleasant were not fancy but were functional. Eleven workers take a break to record this time and place. Judging by the tools, this is a structural maintenance gang likely repairing the track and turntable components. Fourth from the right is yardmaster Ralph Bruno, with the hat and vest. He is the boss as he has a pocket watch chain visibly draped across his vest. It is his responsibility to ensure work does not affect scheduled movements. (Courtesy Howard B. Morris.)

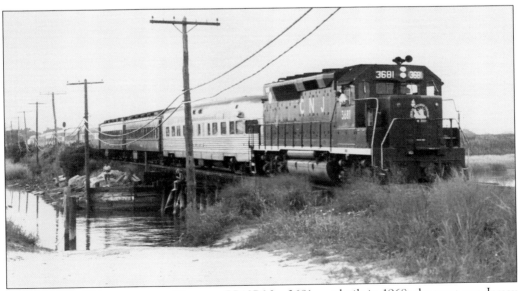

This August 1974 image spans 50 years. GP40P No. 3681 was built in 1968; the next car, Jersey Coast Club, is an ex–Florida East Coast tavern-observation built by the Budd Company in 1947; the two CNJ club cars that follow are from the 1920s; and the remaining coaches were from long-distance Midwestern railroads built in the 1950s, finishing out their lives as commuter coaches. The telephone poles once carried telegraph lines. (Courtesy William J. Coxey.)

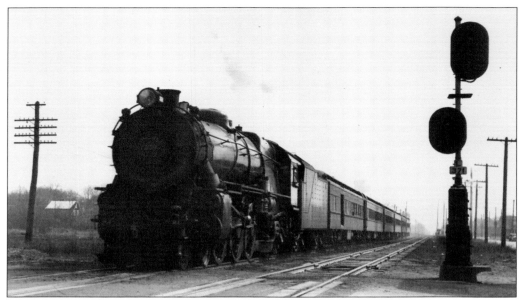

It is a 1938 Sunday afternoon as PRR No. 3753 brakes for the Point Pleasant station ahead. The facing block signal has number 371 on it. This seemingly insignificant number plate tells employees they are at or near milepost 37, with the *1* designating it the first such signal in that mile. The odd number also means it serves westbound trains, just like the odd-numbered trains. Finally, if the lights are all red, they may stop and then proceed slowly. No number plate affixed means stop and do not proceed without special permission. (Courtesy George E. Votava.)

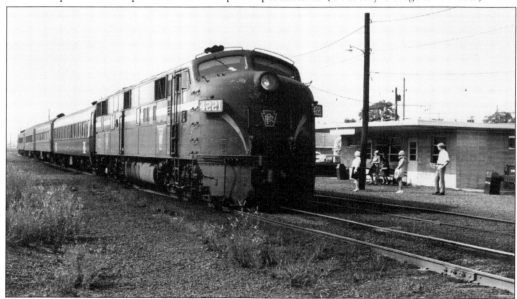

Spartan stations replaced the grander styles. The simple cement block flat-roofed Point Pleasant Beach station is proof. E8 No. 4221 with train No. 1120 looks in good condition. The PRR and NYC merged in 1968, forming the Penn Central. The New Haven Railroad joined the fold on January 1, 1969. Behind the locomotive in this June 1969 view is a New Haven Railroad coach adding to the NY&LB potpourri of equipment. (Courtesy William J. Coxey.)

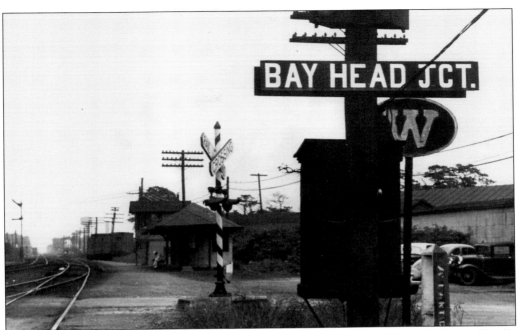

This c. 1930 picture is worth many words. Railroad signs were like mileposts. They officially designated points that corresponded to instructions in rule books and movement forms. The town is called Bay Head, however, the station and this location were called Bay Head Junction, so named as a PRR branch line connected here. In the lower right corner is a cast-iron post dividing the NY&LB from the PRR's Atlantic division. Just behind the station is HO tower, controlling train movements. (Courtesy Peter Rickerhauser.)

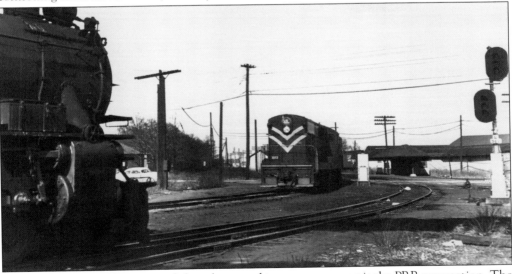

Just 25 years later, HO tower and the other noted items are gone, as is the PRR connection. The block signal is 382 and is farthest away from milepost 0 at the Raritan River. PRR K4s No. 3752 waits before leaving on the eastbound track for CNJ No. 1513, which is stopped to discharge only at Bay Head station. Passengers had to cross over the eastbound track as the station is on one side only. Bay Head Junction became simply Bay Head in 1974. (Courtesy Don Wood.)

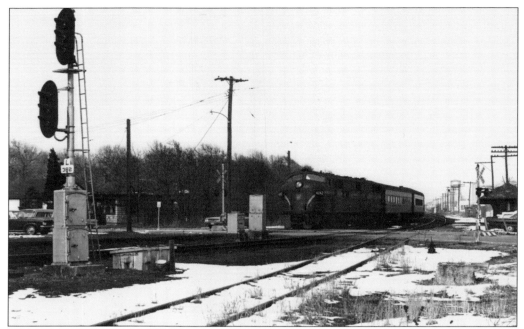

Train No. 1107 from New York has No. 4242 on point. After unloading, it will make the loop track at Bay Head Yard. The loop allowed for turning the entire train without disconnecting cars and engines. It expedited moves during busy seasons and for excursion specials. Some Monmouth Park specials and locomotives from Prudential's extras all came here to turn and make room in otherwise overcrowded yards. (Courtesy William J. Coxey.)

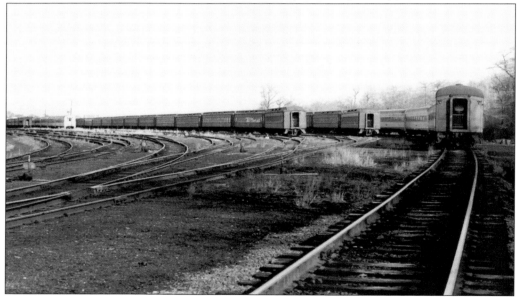

This March 1970 view from the back of Bay Head Yard shows the sharp curvature of the loop. At one point in the curve, it broke out using switches to create 15-yard tracks to stage trains. Coaches were cleaned, watered, and inspected for their next runs. For the most part, the CNJ trains were stored to the right and PRR to the left. (Courtesy William J. Coxey.)

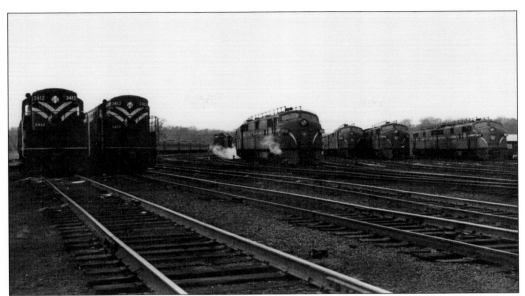

On the opposite end, the locomotives are made ready. Fueled, watered, and inspected, they now face east awaiting their next assignments. Steam leaks from pipes that carry it through the entire train, providing heat inside the coaches. Locomotives had their own steam boilers. There are two CNJ Trainmasters, one GP7, and eight PRR E8s ready. (Courtesy William J. Coxey.)

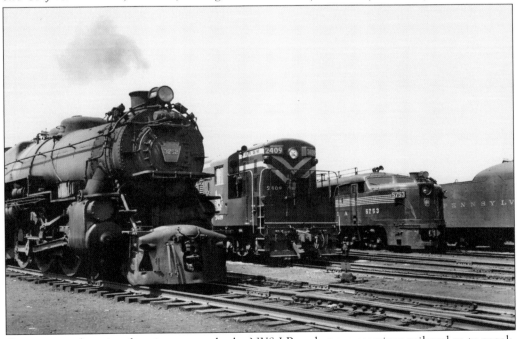

Once again, the mix of equipment made the NY&LB, a shotgun marriage railroad so to speak, most interesting. In August 1956, K4s No. 3752, Trainmaster No. 2409, PA No. 5753, and an unknown PRR steam unit are all together, but not for long. PRR steam had a year to go, the PA would succumb to time. Trainmaster units never lasted their useful life cycles due to wiring problems and opposed pistons creating maintenance headaches. (Courtesy Tom Gallo.)

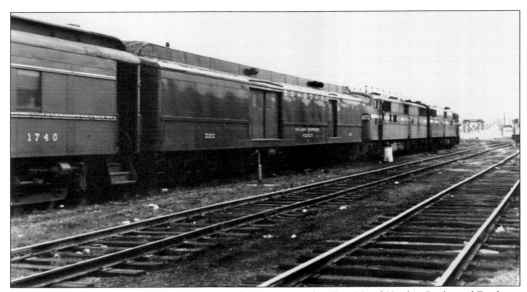

Another unusual visitor through Monmouth County and at Bay Head Yard is Seaboard Railway Express Agency (REA) baggage car. Before United Parcel Service (UPS) and overnight express services, packages went by rail via REA. While not a railroad itself, it had agreements with railroads to haul REA cars over long and short distances, with express deliveries being taken from the train at key points. This car came from the PRR yard in New York where it was available for a quick round trip. PRR and Seaboard operated through service from New York City to Florida. (Courtesy William B. Longo.)

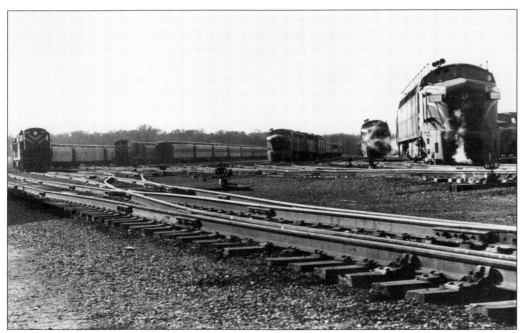

There are no less than four PRR Sharknosed engines in this November 1962 view. The intricate track and switch layout is seen close up. (Courtesy William J. Coxey.)

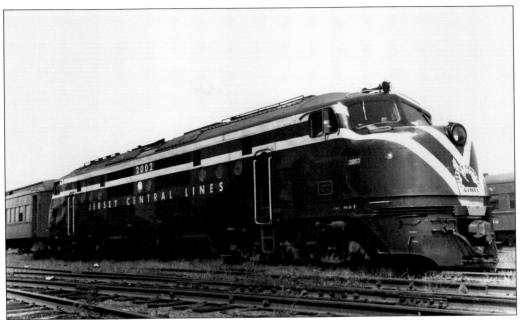

This is the locomotive dedicated to Elmer F. Shinn. CNJ No. 2002 wore the plaque during its daily assignments, which were quite aggressive as the CNJ utilized the first three delivered and ultimately all six in an assignment ritual that caused earlier-than-desired excessive wear and tear. The RDCs would suffer the same pounding but would endure after being rebuilt with parts more readily available from other retired RDCs. The lone six double-enders were doomed. (Courtesy Robert Lorenz.)

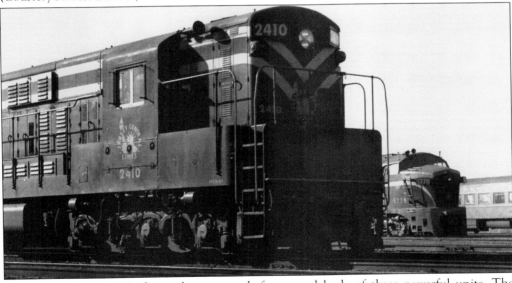

A close-up of No. 2410 shows the mammoth frame and body of these powerful units. The straight climb steps were not a favorite of employees, and many felt the ride was rough inside the cab. Fairbanks Morse built these units but did not stay in the diesel-building business long. EMD units edged out many of the early diesel competitors. Sharknose No. 5718 seems dwarfed. (Courtesy William J. Coxey.)

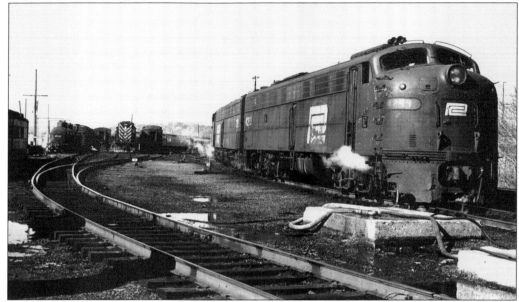

The Penn Central (PC) chose straight black for the locomotives but never achieved that status in its accounting. Running in the red since inception, consolidations and retirement of plants only slowed losses, as new income sources were few. E8 No. 4253 blows off a little steam. A watering hose is seen on the ground. Water was used for making the steam heat. Now unreliable, E8s under PC were run in triples occasionally in hopes of ensuring the train reached South Amboy, as units conked out en route. (Courtesy William J. Coxey.)

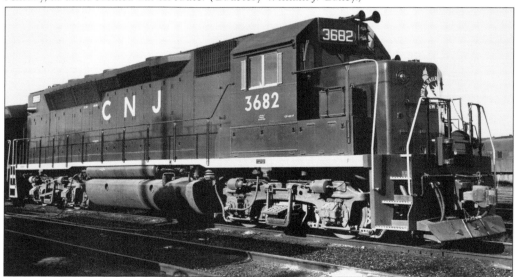

Still new in 1969, CNJ GP40P No. 3682, one of 13, had an extralarge fuel tank to reduce time-consuming fueling needs. They were delivered in blue bodies with yellow striping. The Statue of Liberty emblem lived on, however, the Jersey Central Lines name was changed out in the mid-1960s to Central Railroad Company of New Jersey around the statue's crown. The second P in the GP40P indicated it had head-end power capabilities, meaning electric for coach lighting. It too made steam for the 1920 coaches it pulled and pushed. (Courtesy Don Wood.)

Two

THE PENNSYLVANIA RAILROAD

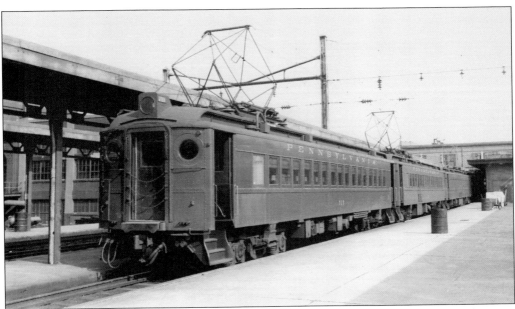

The PRR was a powerful corporation, spreading to 17 states before dwindling into bankruptcy. Within New Jersey, it developed a high-speed main line between Trenton and New York City, forced a partnership with the CNJ to form the NY&LB, and in South Jersey with the Reading Railroad forming the Pennsylvania–Reading Seashore Lines (PRSL). Early Monmouth County travelers had many choices of destinations and directions from which to choose. In the north, Jersey City's Exchange Place station provided connections to the Hudson and Manhattan subway-type system. In Jersey City, steam, diesel, and electric locomotives all traveled into Exchange Place, best described as a stub-end terminal where the PRR offered a ferry to city points until 1950. Here electric multiple units, or MUs, wait for their westbound assignment in June 1952. (Courtesy George E. Votava.)

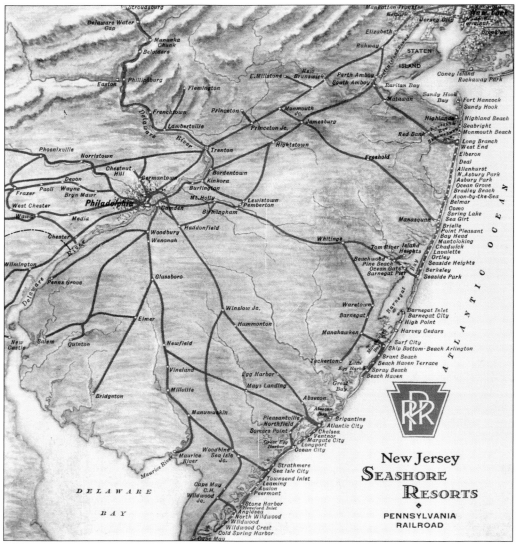

The 1931 PRR's New Jersey network resembled spider cracks in safety glass. Few areas were without service. Starting from the top northeast corner, New York City, Jersey City, and Newark are key points for jobs and connections to the rest of the United States. Diagonally southwest along the PRR's main corridor, Trenton and Philadelphia were a source of state and federal jobs. Sweeping south, the Cape May to Atlantic City shore lines were served by the PRSL. Heading north along the Atlantic Ocean, Tuckerton, Barnegat, and Beach Haven areas can be reached via Whitings. From there, the PRR provided connections from Seaside Park up to Bay Head, Long Branch, and Red Bank. From Sea Girt, the PRR cut west across Monmouth County's farmlands, through the county seat in Freehold, Jamesburg, and Monmouth Junction, connecting back to the PRR's main corridor. (Courtesy Tom Gallo.)

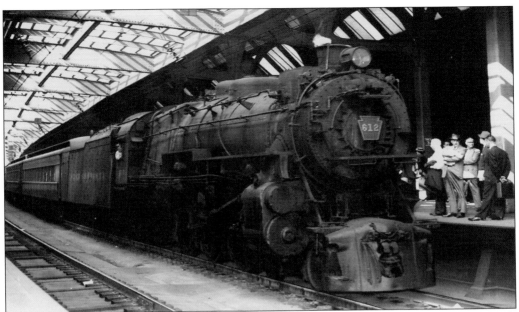

Newark's Penn Station served as the PRR's main station within the state. Daily Monmouth County riders and others from along the route derived their income from office and industrial work in this great city. One major employer was Prudential Insurance Company. It has been a long, hot August day in 1957 at the office, and it is time to go home to the cool Jersey Shore. Waiting on the platform in hats and neckties, this crowd is glad to see the train arrive. Its name is the *Broker*, named so for the stock exchange clientele who patronized it. (Courtesy Don Wood, Joel Rosenbaum collection.)

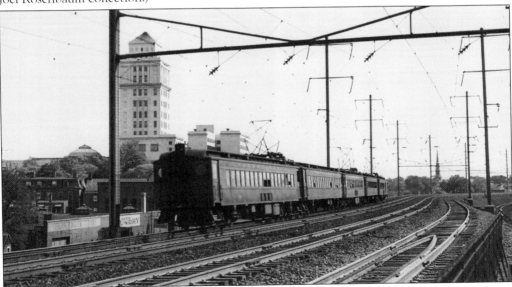

Skirting through Elizabeth, five MUs are on the S curve with the Union County courthouse as a backdrop. The last car is a combine in this May 1937 view. The overhead electric wire system, known as catenary, provided a source of electricity for powering electric units such as MUs, GG-1s, P5As, E44s, and more. (Courtesy George E. Votava.)

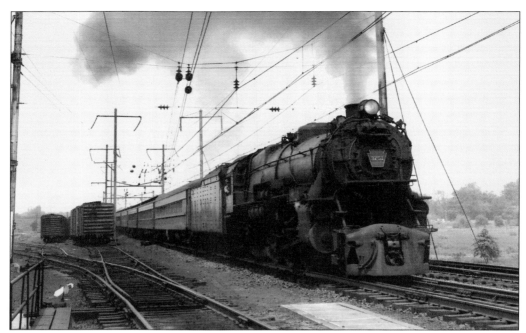

At points where the catenary system stopped, an engine change was required. Until the 1967 Aldene Plan, some PRR trains changed engines at Rahway to prevent congestion at South Amboy during the busy rush hours. Here PRR K4s No. 3751 has coupled up, had its brakes tested, and is accelerating based upon the smoke stream coming from it stack. The yard to the left provided an area for local freight to shuffle cars around without blocking the main. Rahway had many industries receiving rail shipments and exports. (Courtesy Don Wood.)

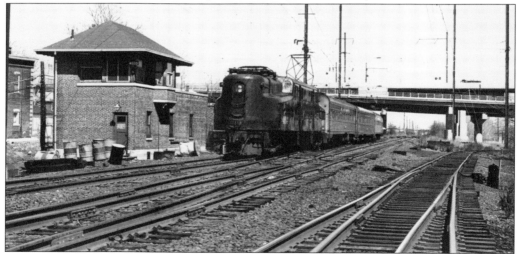

Black PC GG-1 No. 4884 rolls by WC tower, later renamed WOOD, with train No. 3355. This interlocking in Perth Amboy is where the PRR connected to the CNJ to reach the NY&LB. The track on the right allowed eastward PRR trains to pass under the busy CNJ main line to avoid conflicting moves. The Lehigh Valley Railroad (LV), which ended its South Plainfield–Perth Amboy passenger service in 1934, had a freight interchange at Perth Amboy. (Courtesy William J. Coxey.)

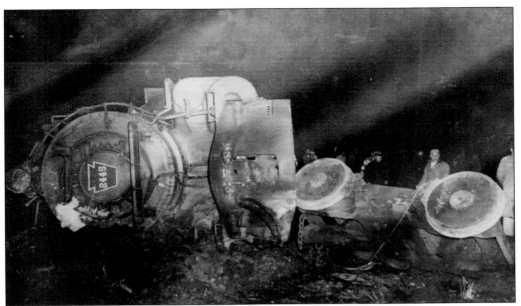

The *Broker* met a grim fate at Woodbridge on February 6, 1951. The engineer failed to slow down as he approached a temporary trestle, causing the train to derail and roll down an embankment. The train was packed with passengers due to a strike on the CNJ. Eighty-four passengers and the fireman, an employee who assists the engineer, were killed and hundreds injured as K4s No. 2445 lay on its side into the night as the tragedy was investigated. (Courtesy Joel Rosenbaum collection.)

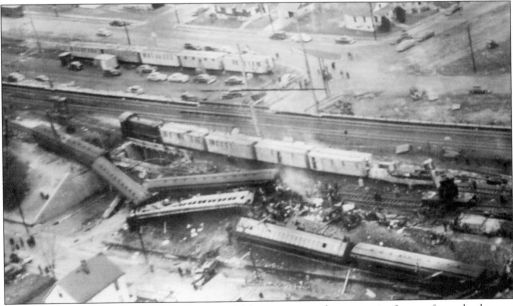

A bird's-eye view shows six coaches tossed like toys onto the street in front of nearby homes that served as relief and triage for survivors. The string of cars in the center and along the road (top) are work trains, on site to provide tools and equipment to restore order. (Courtesy Joel Rosenbaum collection.)

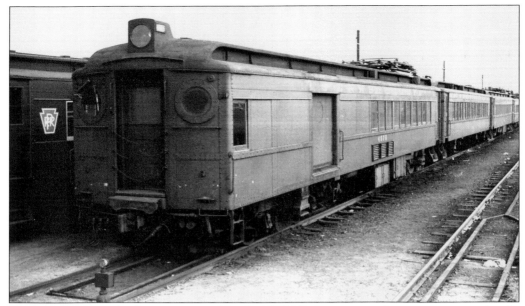

South Amboy was the first town served by the NY&LB. It was not only an important point for early rail travel and ferries to New York, it had large freight and coal facilities. Additionally the Raritan River Railroad interchanged with the CNJ south of the station. A PRR MU No. 4575 and company have the pantographs down as they sit in the MU yard. Pantographs served as the physical point to collect electric power from catenary. When lowered, workers could safely service high-voltage equipment. (Courtesy William B. Longo.)

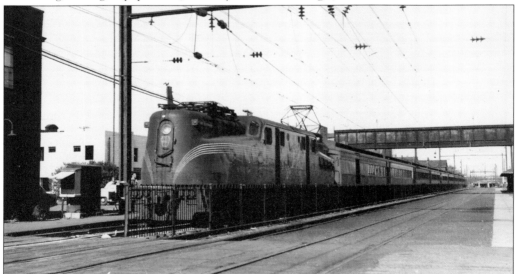

Westward at South Amboy station, GG-1 No. 4907 prepares to cut off its 10-car train and head for the shop area for servicing. The overhead structure served as a pedestrian walkway. The Raritan River Railroad headquarters is barely visible to the left. During the seven-minute engine change, some riders dashed to local stores for a snack or other refreshments before the engine change was complete and the remainder of the journey home began. (Courtesy Railroad Avenue Enterprises.)

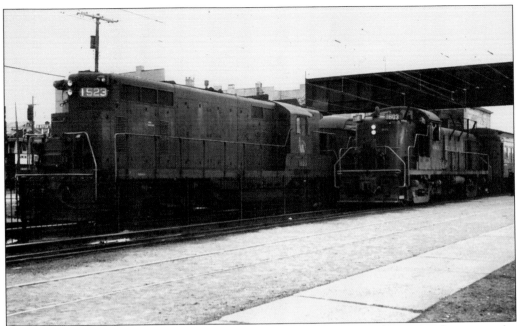

This is an unusual scene even for busy South Amboy. Due to severe long-term damage to the Raritan River drawbridge in March 1966, both railroads provided shuttle trains between South Amboy and Bay Head. CNJ GP7 No. 1523 was a common sight, however, PRR No. 8603 was on a track usually assigned for the other direction and its being assigned to a passenger train was infrequent. (Courtesy Tom Gallo.)

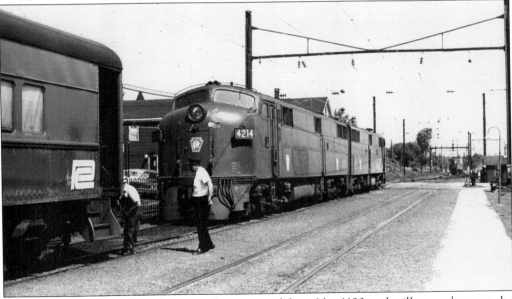

It is June 1970. The E units have just disconnected from No. 1120 and will meander over the main line through switches and curves to the shops. A conductor watches as the mechanic prepares the coupler and hoses. No need to connect steam pipes for heat today. (Courtesy William J. Coxey.)

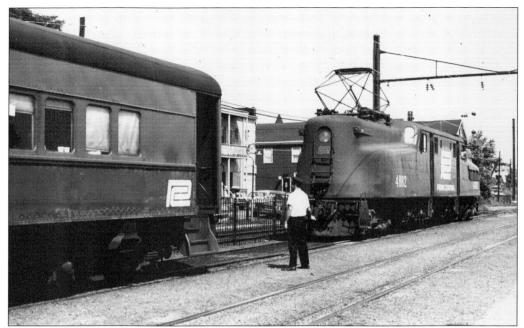

Wearing PC markings, GG-1 No. 4882 slows back gently to couple up, keeping in mind there are people on board the cars. The conductor uses a barely visible slow, low hand movement indicating nice and easy as seen by the engineer hanging out his window. (Courtesy William J. Coxey.)

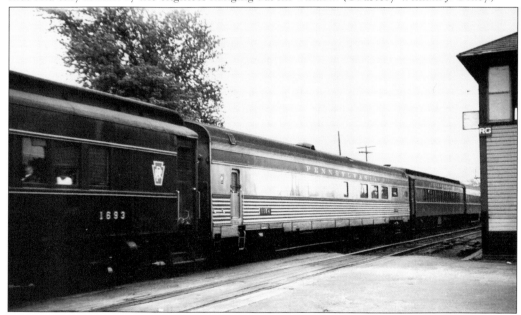

The few trains that had snack or refreshment cars provide coffee and pastries in the morning and light snacks and some liquors in the evenings. PRR lunch counter/tavern lounge No. 1154 is mid-train surrounded by standard coaches having once served on much longer distance runs on the 1952 Budd-built *Congressional*. It has been relegated to the NY&LB today. (Courtesy Tom Gallo.)

There is an added facility on this train for your convenience.

JERSEY SHORE COMMUTERS' BAR

"Sips and Snacks"

SANDWICHES

HAM35 CHEESE30 COMBINATION . . .50
(Ham and Cheese)

POUND CAKE15

BEVERAGES

Rye, Bourbon, Scotch or Canadian *(Straight or Highball)*95
Whiskey Blends *(Straight or Highball)*85
Coca-Cola or Pepsi-Cola .15
Manhattan or Martini Cocktails65
Rum Collins or Cuba Libre80
Vodka Collins or Vodka & Tonic80
Tom Collins or Gin & Tonic75
Beer or Ale .40

Cigarettes30 Cigars — Price Indicated on Box

Breakfast "Quickies"

ORANGE JUICE20 TOMATO JUICE20
DOUGHNUTS 2 for .25
CRULLERS each .10
BREAKFAST BUNS each .10
COFFEE15 MILK15

PENNSYLVANIA RAILROAD

A menu for the PRR's Jersey Shore commuters' bar offers ham-and-cheese sandwiches and a short list of soft drinks and some popular mixed relaxers. It also offered "sips and snacks" to enjoy during the ride. In their heyday, railroads had kitchen and full dining room cars where onboard chefs and short-order cooks prepared meals one would expect to find in a fancy restaurant. Packaged snacks and canned sodas closed out the era of onboard cuisine service.

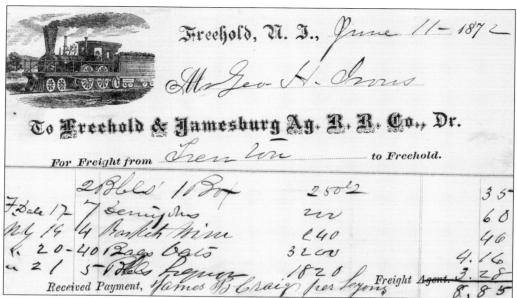

Freehold, N. J., *June 11 - 1872*

Mr Geo. H. Irons

To **Freehold & Jamesburg Ag. R. R. Co., Dr.**

For *Freight from* Trenton _____ to Freehold.

	2 Bbls 1 Box	250 ℔		35
7 Dale 17	7 Settings	2w		60
July 19	4 Baskets Wine	240		46
" 20	40 Bags Oats	3200		4.16
" 21	5 Bbls Liquor	1820		3.28
				8.85

Received Payment, *James W Craig per Lyons* Freight Agent.

The Freehold and Jamesburg Agricultural Railroad (F&J) connected those two key towns and ultimately reached Trenton to the west and Sea Girt to the east. Passing through Freehold, the county seat, this line connected mostly rural villages to the big cities. This June 11, 1872, invoice is for services provided carrying merchandise to Trenton at a cost of $8.85 payable to the F&J. (Courtesy Tom Gallo.)

5.05	33.3	Lv **Trenton, N. J.**	Ar	8.42
5.20	43.0	" Princeton Junction, N. J.	Lv	8.27
----	44.5	" Plainsboro, N. J.	"	8.22
5.30	49.0	Ar Monmouth Junction, N. J.	Lv	8.17
5.30	49.0	Lv **Monmouth Junction, N. J.**	Ar	8.17
5.38	54.6	" Jamesburg, N. J.	Lv	8.06
5.51	61.4	" Englishtown, N. J.	"	7.52
6.01	66.1	" Freehold, N. J.	"	7.39
6.15	73.6	" Farmingdale, N. J.	"	7.26
6.24	78.6	" Allenwood, N. J.	"	7.14
6.31	81.5	" Manasquan, N. J. (Penna. R. R. Sta.)	"	7.06
6.34	82.1	" Sea Girt, N. J.	"	7.03
6.37	83.5	" Spring Lake-Spring Lake Heights, N. J.	"	7.00
6.41	85.6	" Belmar, N. J.	"	6.56
----	86.4	" Avon-by-the-Sea, N. J. (Neptune City)	"	6.53
6.44	87.3	" Bradley Beach, N. J.	"	6.50
6.47	88.2	" **Asbury Park** } N. J.	"	
	88.2	" **Ocean Grove** }	"	6.47
6.49	88.9	" North Asbury Park, N. J.	"	6.44
6.53	89.7	" Allenhurst, N. J.	"	6.41
7.00	93.9	" **Long Branch, N. J.**	"	6.35
7.10	99.9	Ar Red Bank, N. J.	Lv	6.25

This portion of an April 29, 1962, public schedule shows two trains remaining. To the left is the running time and stops of PRR train No. 812 operating Monday through Friday. The next column shows mileage points, although many are not consecutive due to connecting from one rail line to another. The right column shows returning train No. 805, which also did not run Saturdays and Sundays. (Courtesy Tom Gallo.)

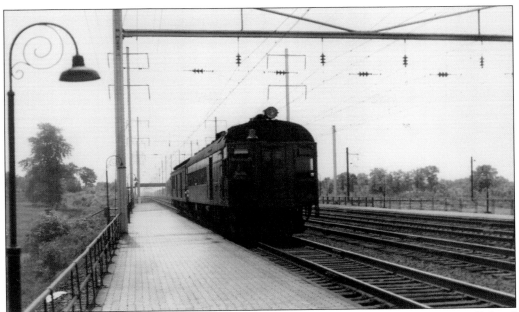

A most unusual piece of railroad equipment was the gas electric car. Its nickname, "Doodlebug," reflects its awkward exterior. It handled main line movement well, as seen in this 1953 Princeton Junction image, however, it was mostly assigned branch line functions, doodling its way back and forth in service that for whatever reason could not be discontinued. (Courtesy John Brinckmann.)

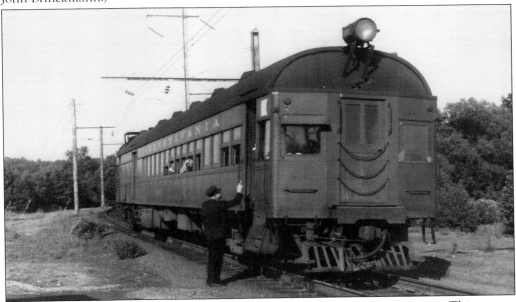

This close-up may convince readers that doodlebug was as good a nickname as any. This car was a combine, which allowed for some light newspaper or mail services, further saving money on operations. This is Monmouth Junction, a connecting point to the PRR's high-speed four-track main line between New York City and Trenton, extending as far north as Boston and south to Washington, D.C. (Courtesy John Brinckmann.)

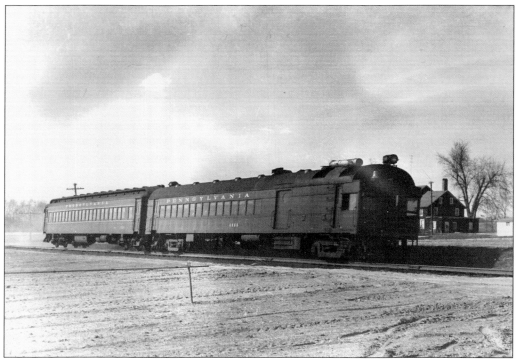

Tilting away, this two-car set clips along in Allenwood. Doodlebug No. 4446 and a regular coach in May 1954 cut through farmland. Freshly tilled soil in the foreground and the bare trees indicate spring planting is not far away. (Courtesy North Jersey Electric Railway Historical Society.)

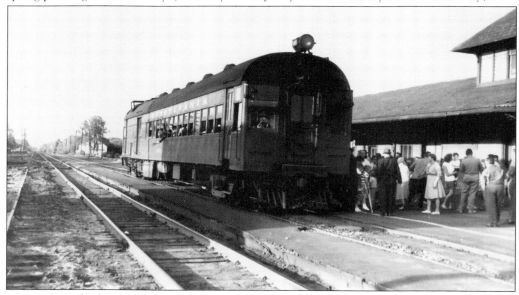

At Sea Girt, the last run of the Doodlebug and the Trenton service brings out more riders than the car has seen in months collectively. Many schoolchildren rode the Doodlebug before busing became the mode. Some riders worked on their degrees by studying on board, which also helped pass the time. (Courtesy John Brinckmann.)

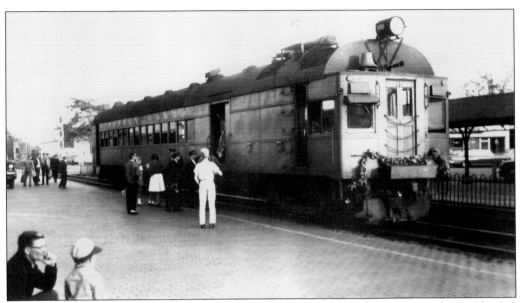

This train is all dressed up with wreathing but has no place to go. The last run of train No. 812 at Red Bank on May 29, 1962, closed an era on the PRR F&J passenger service. In the final years, most of the passengers were Catholic high school girls commuting between Freehold and Cathedral High School in Trenton. (Courtesy John Brinckmann.)

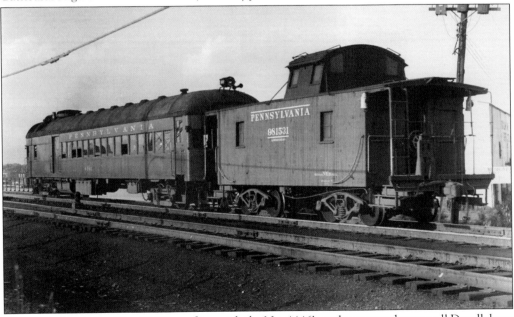

Compare Doodlebug No. 4640's roofline with the No. 4446's and one sees that not all Doodlebugs are alike. At Belmar in 1957, PRR caboose No. 981531 is along for the ride. It did not provide any passenger service purpose, the authors believe, other than to assure the movement of this train shunted (activated) the track circuits for signaling purposes. The Doodlebug alone would not ensure positive shunting and might cause a signal to not go to red when it should. (Courtesy North Jersey Electric Railway Historical Society.)

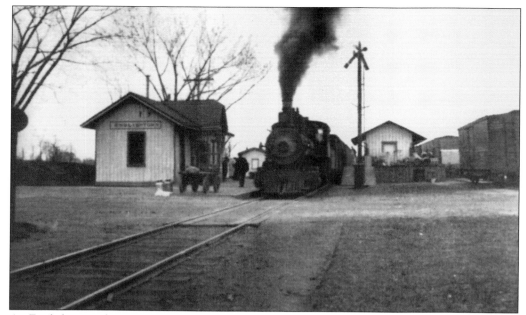

At Englishtown there is a lot happening. From the left is the small wooden station with its oversized dormer providing some shelter. Adjacent is a baggage wagon with one sack of mail. On the ground are two milk cans. The tall mast is a semaphore signal with blades downward. It was manually operated, and the station agent could signal trains to make a special stop. On the freight station platform at right are barrels, sacks, and many more commodities coming or going. To the right is a string of boxcars being loaded. (Courtesy Tom Gallo.)

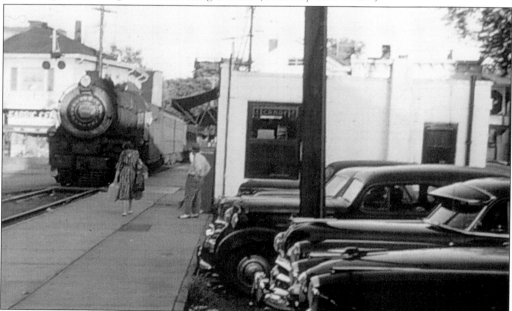

PRR's Freehold station on Main Street was a one-story brick structure with a generous roof and awning with a built-in gutter system to provide shelter from sun and snow. Just crossing Main Street is a Sunday afternoon Trenton-bound train in 1954. (Courtesy Tom Gallo.)

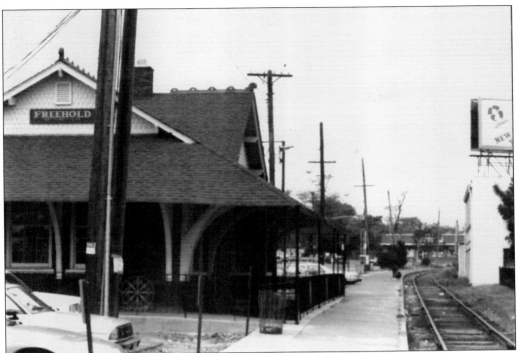

Looking toward Jamesburg from Main Street, the Freehold station and platform have not seen passenger service for years, however, the local freight does a round-trip once a week to service the few lumber companies still using rail service. (Courtesy Joel Rosenbaum.)

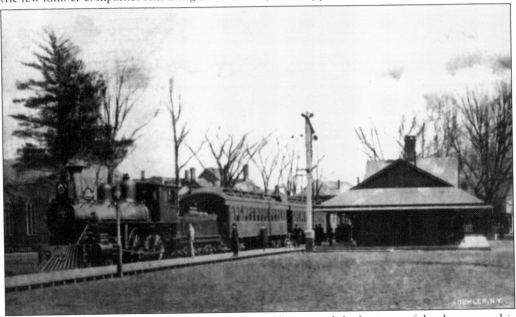

In the early 1900s, top hats and vests, fine-trimmed lawns, and the business of the day create this setting at Freehold. The arrival of a train in town was exciting as it and the crew brought mail, newspapers, gossip, and goods from the big cities. (Courtesy Tom Gallo.)

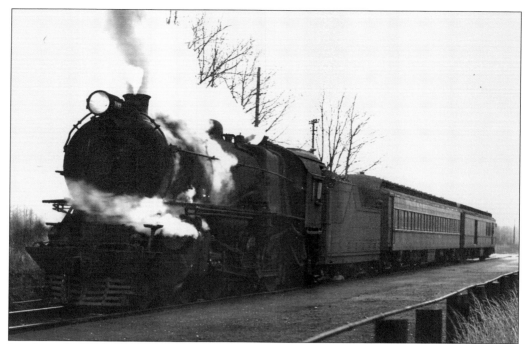

Just down the road a piece from Freehold (7.5 miles) is Farmingdale, a nice town with rural charm and a crossroad for the CNJ and PRR over one of Monmouth County's railroad diamonds. On a cold day in January 1953, PRR No. 1813, a coach, and an RPO are at the dusty cinder platform with steam escaping into the crisp air. (Courtesy North Jersey Electric Railway Historical Society.)

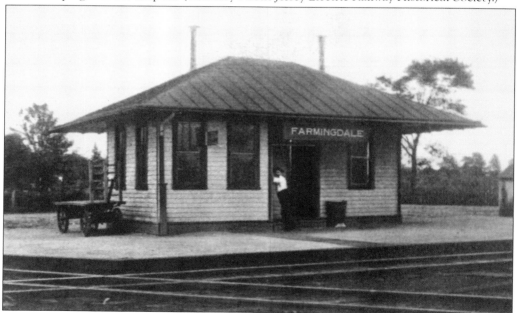

The Farmingdale station seen here was later expanded to accommodate growing business. It served both the CNJ and PRR. In the foreground is the diamond track crossing. The PRR's *Sea Breeze* and the CNJ's *Blue Comet* almost collided at this site. (Courtesy Tom Gallo.)

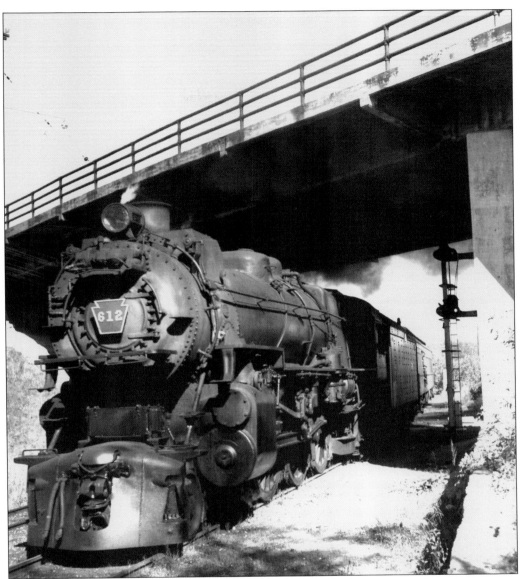

PRR K4s No. 612 has the honor of hauling a special excursion under Route 71 in Manasquan in 1957. The semaphores (signals) at right under the roadway overpass are at a stop for any train that might have been heading toward the special. Such excursions provided day-trippers a nostalgic ride behind retired locomotives and over trackage that had not seen passenger travel for years. (Courtesy Don Wood.)

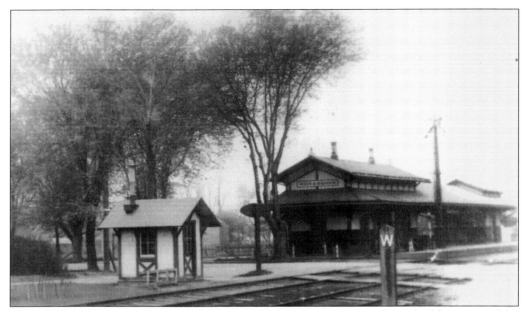

The PRR's Manasquan station facility was substantial, consisting of two buildings joined by a canopy roof. In the forefront is the watchman shanty with what appears to be a fresh coat of paint. The W to the right is the PRR's standard whistle board, a slender cast-iron flat post. (Courtesy Tom Gallo.)

Dist	SOUTHWARD.	WEEK-DAYS.								
		289	271	273	701	275	565	287	277	285
49.0	LONG BRANCH.......	5.30	9.20	10.50	11.30	1.55	2.40	4.05	4.35	5.00
49.7	West End............. }									
49.7	Hollywood............ }	5.33	9.22	10.53	11.33	1.58	2.42	4.08	4.38	5.03
51.3	Elberon	5.38	9.26	10.57	11.37	2.02	2.47	4.12	4.42	5.07
52.7	Deal Beach	f5.41	f9.29	c11.00	c11.40	f2.05	c2.50	f4.15	c4.45
53.6	Interlaken (Loch Arbor).	f5.43	f9.31	c11.03	c11.43	f2.08	c2.53	f4.18		
54.4	North Asbury Park,......	5.44	9.33	11.05	11.45	2.10	2.55	4.20	4.49	5.13
54.7	Asbury Park........... }									
54.7	Ocean Grove.......... }	5.50	9.36	11.08	11.47	2.13	2.58	4.23	4.52	5.15
55.7	Bradley Beach..........	f5.52	f9.38	c11.10	f2.15		
57.1	Avon	f5.54	9.41	c11.12	c11.51	f2.17	c3.03	f4.27	c4.56	c5.19
57.4	Belmar.................	5.57	9.44	11.15	11.54	2.20	3.05	4.30	4.59	5.21
58.4	Como..................	f6.00	f9.47	c11.18	c11.57	f2.23	c3.08	f4.33	c5.02
59.4	Spring Lake.............	6.03	9.50	11.21	12.00	2.26	3.11	4.36	5.05	5.26
60.8	Sea Girt................	6.07	9.53	11.25	12.04	2.30	3.15	4.40	5.09	5.29
61.5	Manasquan...	6.09	9.55	11.27	12.07	2.33	3.17	4.43	5.11
62.1	Brille..................	f6.11	f9.56	c11.29	c12.09	f2.35	c3.19	f4.45	c5.13
63.5	Point Pleasant.....Arrive	6.16	10.00	11.35	12.15	2.40	3.26	4.51	5.20	5.35
63.5	Point Pleasant.....Leave	7.08	11.45	2.48			5.20	5.42
65.0	Bay Head	7.15	11.52	2.53			5.25	5.47
67.4	Mantaloking	7.21	11.59	3.00	Will commence running June 30th.	Will commence running June 30th.	5.32	5.53
70.7	Chadwick...............	7.27	12.07	3.07			5.39	5.59
71.9	Lavallette...............	f7.30	f12.11	f3.10			f5.42	f6.05
72.9	Ortley.................	f7.32	f12.14	f3.13			f5.45	f6.08
75.5	Berkeley..............	7.35	12.18	3.18			5.50	6.13
76.1	Sea-Side Park..........	7.38	12.21	3.22			5.55	6.16
77.6	Barnegat Pier..........	7.44	12.27			6.01	6.22
80.8	Island Heights....Arrive	7.56	12.39			6.20	6.34
83.1	TOM'S RIVER.........	7.57	12.41			6.22	6.33

(Note: Column 277 is marked "Runs south of Point Plea[sant]".)

Service between Long Branch and Tom's River was a 34-mile trip on this July 1, 1894, schedule. Stations having an f indicated a flag stop. This meant if no one was standing on the platform or were on the train and wanted off, the train would keep going. (Courtesy Joel Rosenbaum.)

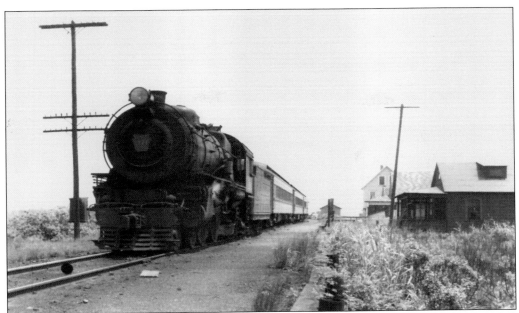

At the Barnegat Pier station on July 4, 1948, locomotive No. 1771, an E6s, powers train No. 998 to Camden. Rail service north to Point Pleasant ended in December 1946, when the trestle across Barnegat Bay burned down. In an earlier time, Barnegat Pier station was actually on the trestle, thus the name. The flat terrain in the background tells it is not far from the Atlantic Ocean. (Courtesy C. Norman Lippincott, Frank C. Kozempel collection.)

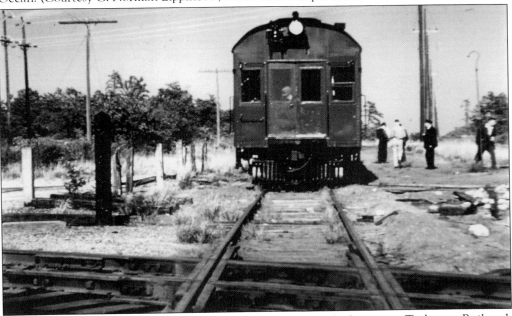

A PRR rail motorcar is seen at Whitings, once a junction for the long-gone Tuckerton Railroad. The PRR used this fuel-efficient equipment requiring less crewmembers in the final years of Camden-Whitings-Tom's River passenger service, discontinued on June 21, 1952. In the foreground is the CNJ diamond perpendicular to the Doodlebug. (Courtesy Tom Gallo.)

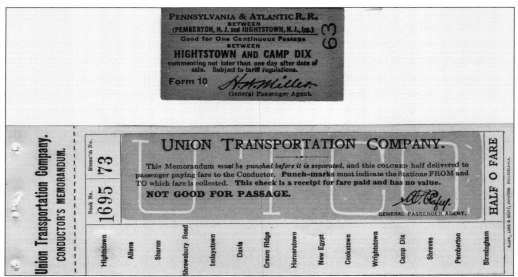

PENNSYLVANIA & ATLANTIC R. R.
BETWEEN
(PEMBERTON, N. J. and HIGHTSTOWN, N. J., inc.)
Good for One Continuous Passage
BETWEEN
HIGHTSTOWN AND CAMP DIX
commencing not later than one day after date of
sale. Subject to tariff regulations.
Form 10
H. H. Miller
General Passenger Agent.

63

Union Transportation Company.
CONDUCTOR'S MEMORANDUM.

Memo'm No. 73
Book No. 1695

UNION TRANSPORTATION COMPANY.

This Memorandum *must be punched before it is separated*, and this COLORED half delivered to passenger paying fare to the Conductor. **Punch-marks** must indicate the Stations FROM and TO which fare is collected. **This check is a receipt for fare paid and has no value.**

NOT GOOD FOR PASSAGE.

A. Clafet.
GENERAL PASSENGER AGENT.

ALLEN, LANE & SCOTT, PRINTERS PHILADELPHIA.

HALF O FARE

Hightstown | Allens | Sharon | Shrewsbury Road | Imlaystown | Davis | Cream Ridge | Hornerstown | New Egypt | Cookstown | Wrightstown | Camp Dix | Shreves | Pemberton | Birmingham

The Union Transportation Company, also listed as the Pennsylvania and Atlantic Railroad Company, was a short-line railroad. It operated between Birmingham and Hightstown, passing through an extended leg of western Monmouth County. Stations Sharon through Hornerstown were within Upper Freehold Township. The line served Camp (later Fort) Dix at Wrightstown. (Courtesy Tom Gallo.)

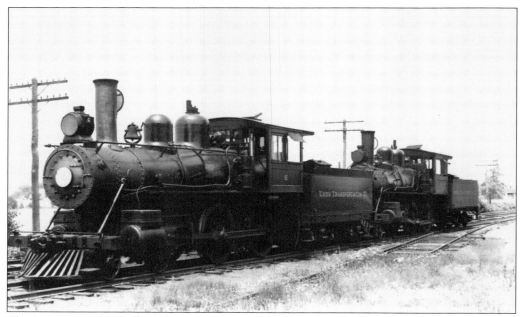

The line survived into the PC era with limited freight traffic. It operated one steam engine in revenue freight service up to 1959, when a PRR 44-ton diesel switcher became the final motive power for this railroad. In its earlier heyday, the railroad required more than one locomotive, such as steam engines No. 6 and a companion seen here. (Courtesy John Brinckmann.)

Three

THE CENTRAL RAILROAD OF NEW JERSEY

The CNJ had its beginning in central New Jersey in 1849. Its main line reached for New York City and the rich coal fields of Pennsylvania. Its southern division route to southwestern New Jersey and the Delaware River never gained the prominence anticipated. The NY&LB, built solely by the CNJ, was a good venture. Day trips and outings to resorts on the shore became popular, as did horse racing. Typically, as each new rail line became profitable, improvements where made. The main line became four tracks wide, six where local industries required daily deliveries. The NY&LB, with new partner PRR, became a double-track operation with drawbridges and swing bridges to allow for equally busy maritime movements. The timetable cover shown here highlights some of the key towns served in 1931. The *Blue Comet* became the most famous of trains to serve Monmouth County as well the entire CNJ system.

New Jersey Central

Time tables

BETWEEN

NEW YORK NEWARK

AND

PERTH AMBOY MATAWAN

RED BANK LONG BRANCH

ASBURY PARK—OCEAN GROVE

POINT PLEASANT FREEHOLD

ATLANTIC HIGHLANDS

HIGHLANDS SEA BRIGHT

IMPORTANT NOTICE
The time of trains shown in this time table is Eastern Standard Time; add one hour for Daylight Saving Time

THE ROUTE OF
"THE BLUE COMET"

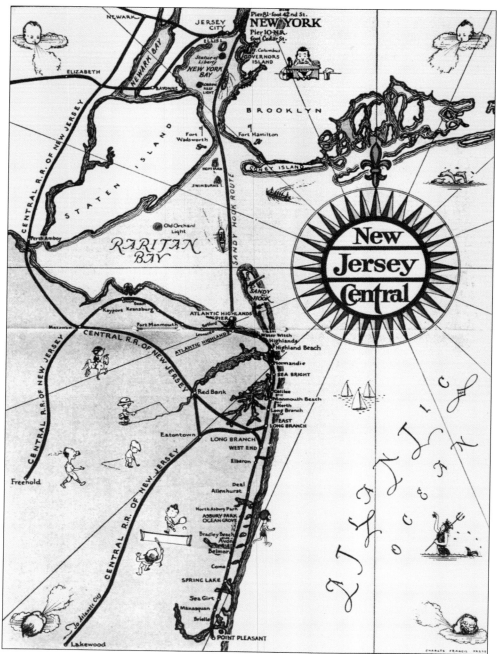

An expressive map of the CNJ attracts business and makes it easy to select one's destination. New York, Newark, and Jersey City appear at the top (north). Swinging left and downward is the series of rail lines leading to the NY&LB, Freehold and Seashore branches, Red Bank, and the southern division to Farmingdale and Atlantic City. The Sandy Hook route is shown sailing directly from New York City to Atlantic Highlands Pier, where one's train for shore points will be waiting. The CNJ was also known as New Jersey Central and Jersey Central Lines. (Courtesy Tom Gallo.)

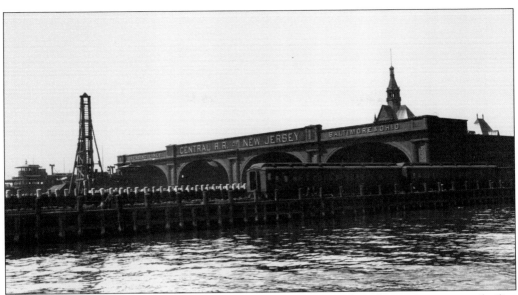

The CNJ headquarters was in Jersey City. This huge rail yard and engine-servicing facility covered acres of the waterfront. A beautiful grand terminal, completed around 1914, served through 1967. It had four ferry slips and 20 tracks under shed cover to accommodate the massive transfer from train to ferry. The pilot house of a ferry is seen at left, with stored railcars to the right. (Courtesy William B. Longo.)

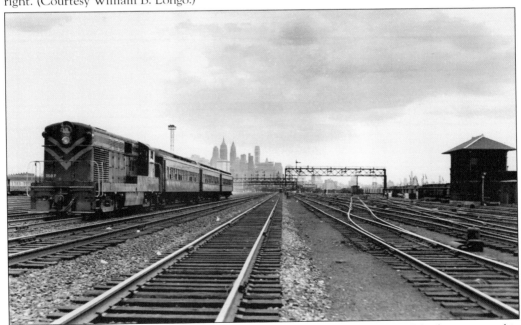

The New York skyline in the background seems miniaturized, however, Manhattan was big business for New Jersey railroads, many of which had offices there even if they had no direct track connections. It looked good on the stationery to indicate they were a New York business. CNJ No. 1507 sprints three cars west past A tower on the right. The sprawling track system is exemplified here in 1954. (Courtesy Don Wood.)

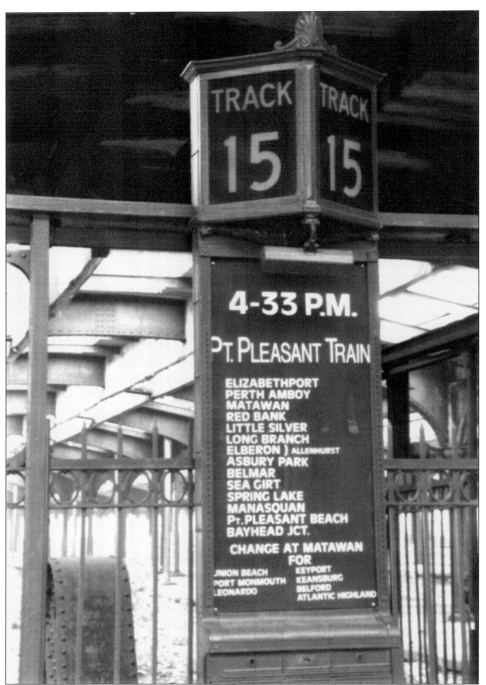

TRACK TRACK
15 15

4-33 P.M.
Pt. PLEASANT TRAIN

ELIZABETHPORT
PERTH AMBOY
MATAWAN
RED BANK
LITTLE SILVER
LONG BRANCH
ELBERON) ALLENHURST
ASBURY PARK
BELMAR
SEA GIRT
SPRING LAKE
MANASQUAN
Pt. PLEASANT BEACH
BAYHEAD JCT.

CHANGE AT MATAWAN
FOR
UNION BEACH KEYPORT
PORT MONMOUTH KEANSBURG
LEONARDO BELFORD
 ATLANTIC HIGHLAND

Serving the public included making travel selections and options easy and convenient, especially if a change of trains or ferry or bus connections were required. In the grand concourse, signs were posted at each gate for that purpose. The 4:33 p.m. Point Pleasant train will leave from track 15. Changes could be made at Matawan for Keyport, Union Beach, Keansburg, Port Monmouth, Belford, Leonardo, and Atlantic Highlands. (Courtesy Tom Gallo.)

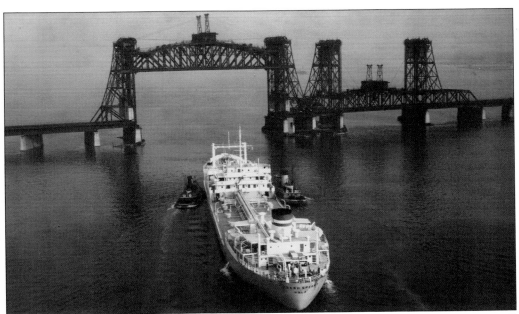

To reach their desired destinations, railroads had to bridge, fill, bore, blast, and tunnel small and large natural geographical terrains, keeping in mind level tracks require the least amount of horsepower and tractive effort on heavy trains. To cross the Newark Bay, this second bridge was constructed in 1928. The largest of its kind, it featured two openings for marine traffic and has four tracks its entire length. Taken from 300 feet, two tugs guide a ship through the fully raised span. (Courtesy Tom Gallo.)

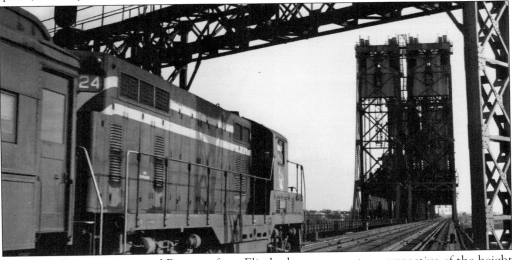

In this engineer's view toward Bayonne from Elizabethport, one gets a perspective of the height of the massive lift towers. At mean high water, the clearance was 135 feet. The entire bridge span was 7,147 feet between bulkhead lines. On January 3, 1955, the rail traffic was stopped for bridge openings a total of 28 times. Since ships had preference, commuters and freight trains had to wait, even during rush hours. On January 18, 1955, 6,066 passengers on 17 different trains were delayed 144 minutes. Railroads used these statistics to petition for relief from peak-hour openings to no avail. (Courtesy Don Wood.)

The authors had no intent to overdramatize railroad disasters. However, there is no denying they occurred. The engine crew and 48 passengers drowned on September 15, 1958, when, for reasons yet to be fully accepted, CNJ train No. 3314 from Bay Head plunged through the open drawbridge despite red signals being displayed. Among those lost were Mayor John Hawkins of Shrewsbury and former Yankee baseball player George Stirnweiss. One of the two diesels, No. 1526, is seen here after being retrieved from the bay bottom. (Courtesy Don Wood.)

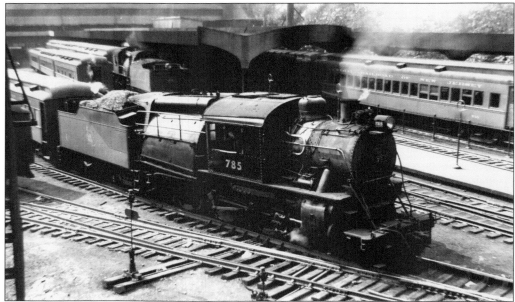

To reach the heart of Newark's Broad Street business district, the CNJ built the Newark and New York branch, connecting to both Jersey City and Elizabethport. Broad Street Newark had a deceptively small street frontage, which opened to a huge waiting room with a high ceiling once inside. Four tracks under canopy provided convenient access to the train. Camelback No. 785 and coaches are on the station tracks in July 1947. (Courtesy Railroad Avenue Enterprises.)

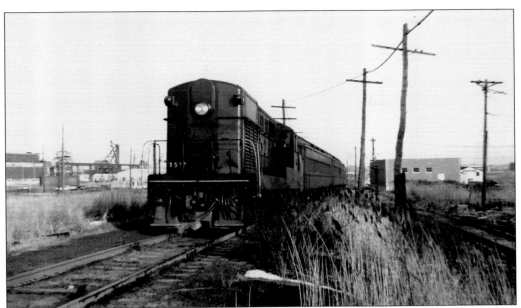

The Newark and New York branch served the Westinghouse complex on the Passaic River at Kearny. Truncated by the loss of the extensively damaged ship-battered bridge, the line was served by trains between here and Elizabethport for transfers. Freshly painted in the drab green with no fancy stripes is Baby Trainmaster No. 1516 and its typically short train already turned for the trip home. (Courtesy Railroad Avenue Enterprises.)

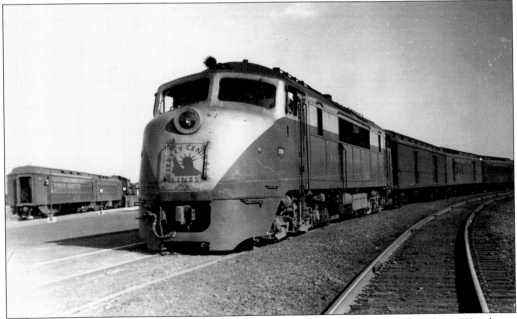

A meet at Elizabethport, CNJ's main shop and freight classification center after the 1960s, shows shore-bound double-ender No. 2004, a baggage car, and RPO connecting to a two-car shuttle lead by a GP7. It is the early 1950s, so the authors will not speculate on where the shuttle is going or coming from, as there were several possibilities. (Courtesy Railroad Avenue Enterprises.)

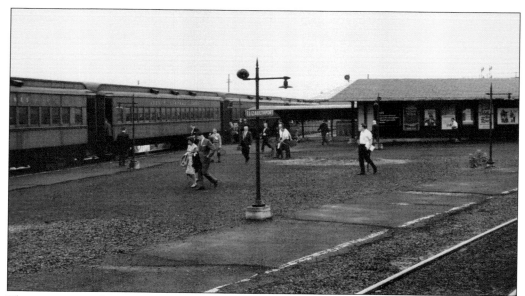

The race is on! Commuters step it up to catch another connecting train at Elizabethport, or "E'port," as employees called it. The Broadway play *Fiddler on the Roof* is advertised on a poster. This train is stretched across the four track main line diamond behind the station building. Likely a scheduled move, it will leave on time, otherwise no other trains can pass through here. (Courtesy William B. Longo.)

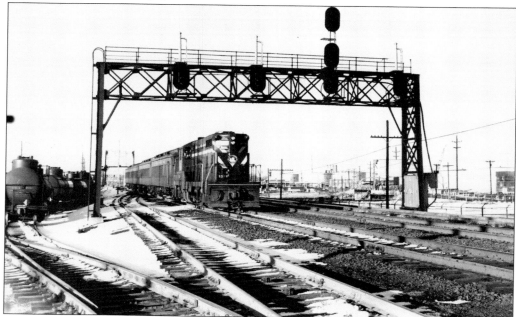

New Jersey has long been known for its industrialized areas, well documented here in the Woodbridge and Perth Amboy areas. Splicing through the complexes on both sides, the CNJ's Elizabethport and Perth Amboy branch provided through access to the NY&LB. GP7 No. 1529 heads west on a very sunny day with leftover snow on the ground. (Courtesy Railroad Avenue Enterprises.)

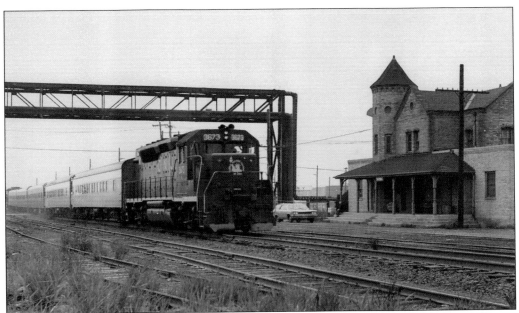

Near the same location, the CNJ's 1974 special service Raritan to Bay Head *Mermaid* train passes under the pipes of a fuel-processing company at the Barber (Perth Amboy) station. At this time, the Barber station is no longer used by passengers but is used by drill crews for sign-up and locker purposes. GP40P No. 3674 has five cars, and another GP40P is pushing allowing for quick reversing of directions at West Eighth Street, Bayonne station. (Courtesy Railroad Avenue Enterprises, photograph by Bob Pennisi.)

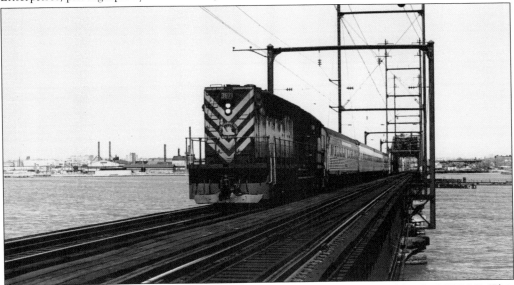

Train No. 5357 passes over the Raritan River drawbridge built and owned by the NY&LB. This is the second bridge built here. The original NY&LB bridge here was the longest of its type at the time. The distant end of the bridge behind the train is milepost 0, located in Perth Amboy. The swing span is directly behind the train. The industrialized shore area left provided the CNJ and LV plenty of chemical movement business. (Courtesy William J. Coxey.)

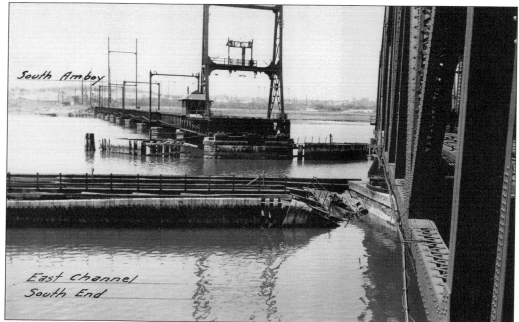

On March 3, 1966, a tanker ship rammed the protective fender system and the 327-foot-long swing span. Rail traffic was shut down for six weeks as a special bus operation was established to carry rail riders between South Amboy and Perth Amboy to shuttle trains. Damages were estimated at $250,000 but were actually more than $1.5 million. CNJ's chief engineer Benjamin J. Minetti reported that 138 tons of steel replacement parts were made. (Courtesy Tom Gallo.)

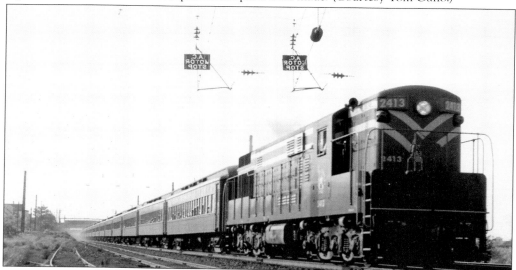

Leaving South Amboy Station, Trainmaster No. 2413, the last of CNJ's order of 13, grips the rails, setting its 14 cars in motion west for Bay Head Junction. Although the CNJ did not operate electric overhead locomotives, crews were safety trained in electrified territory, especially staying off the tops of equipment, something of lesser concern elsewhere. The end of the PRR's catenary system is visible by the reversed cut-out signs overhead, "A. C. Motor Stop" (alternating current). (Courtesy G. Jack Raymus.)

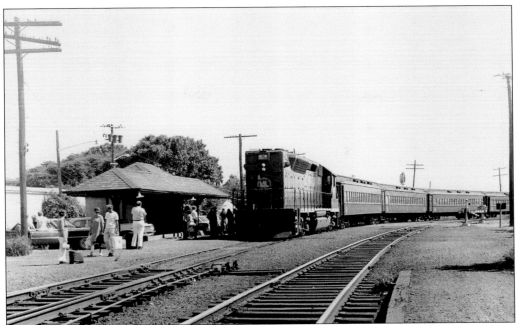

Long end out, GP40P No. 3676 gingerly pulls into Bay Head station, where it appears people are heading back home to the north. It is July 1971. HO tower is gone. If a train had to cross over to another track, the crew would have to do it themselves using locked switch controls. The angled cross arm on the telephone pole holds up wires no longer used for telegraphs and telephones. (Courtesy Railroad Avenue Enterprises, photograph by Bob Pennisi.)

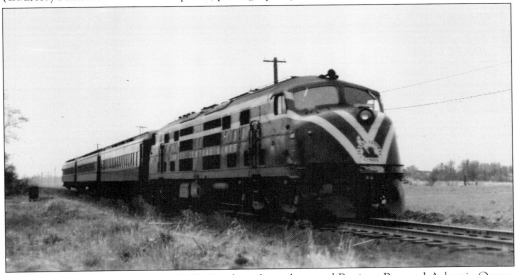

Branching off at Matawan, the CNJ's Seashore branch served Raritan Bay and Atlantic Ocean waterfront towns. Showing off their versatility in Keyport, double-ender No. 2004 is excessive power for a three-car shuttle train. Bob Hoeft, CNJ veteran employee conductor, explained when the double-enders were new, some engineers misjudged the braking distance needed when few cars were in the consist. That resulted in passing the station platform until they got used to it. (Courtesy Marie and Norman Wright.)

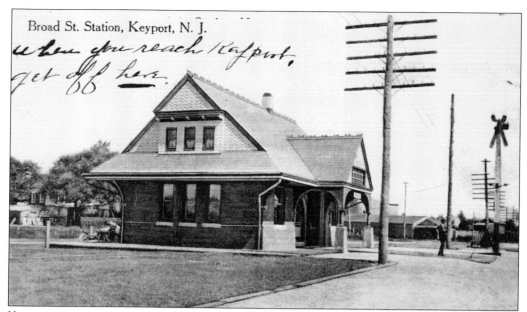

Broad St. Station, Keyport, N. J.

when you reach Keyport, get off here.

Keyport was an important town focused on shipping over waterways and shipbuilding. Community leaders could not gather enough stock subscriptions to get the NY&LB tracks through town, settling for a branch line and early stagecoach connections. Nonetheless, the station building was quite well adorned, being of brick, wood, and an architecturally challenging roof design. The inscription reads, "When you reach Keyport, get off here." (Courtesy Keyport Historical Society.)

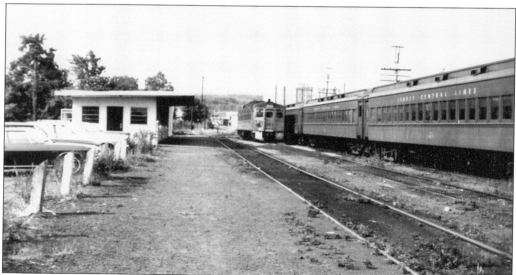

Becoming the new terminus in 1958, Atlantic Highlands served as the yard and crew sign-up point. The 1952-built cement block, flat-roof station is functional without frills, just like Point Pleasant's new station. It is a July 1966 weekend. The single RDC and adjacent coaches are all sitting out the weekend unneeded. One lone Budd car is all that business warrants on weekends. By November 2, 1966, none of the equipment would be here, as passenger service was abandoned. (Courtesy William B. Longo.)

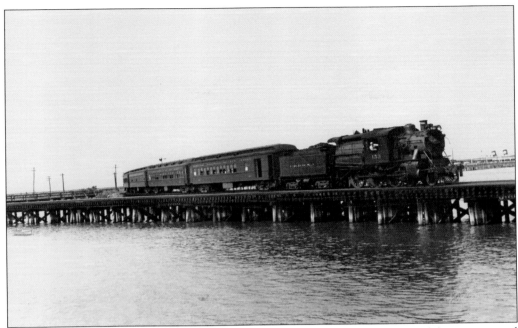

If one wants to go there, one must deal with the geography. The CNJ built an elaborate pier and wye interlocking over the waters at Atlantic Highlands to accommodate the Sandy Hook route ferry services originally located on Sandy Hook. The wye allowed for turning trains and through service from here to East Long Branch. Camelback No. 153 leaves from the pier station after boarding people off the ferry in August 1938. (Courtesy George E. Votava.)

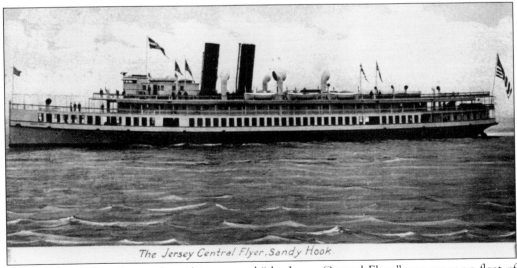

The *Sandy Hook*, nicknamed on this postcard "the Jersey Central Flyer," was among a fleet of steamboats that served the same service, "Sandy Hook Route." Regular service was pleasurable with dining on board available. Special moonlight cruises offered spectacular nighttime sky settings at a time before home television educational documentaries. (Courtesy Tom Gallo.)

The boat-train service from Atlantic Highlands pier ended in September 1941. During World War II, the service was not restored due to dangerous U-boat activity in the area. The U.S. Army took control of the CNJ's SS *Sandy Hook* to provide troop transport to New York Harbor army facilities. After World War II, the pier was used for a boat-bus service between New York and Monmouth Park with Boro Bus Company providing bus service. (Courtesy Motor Bus Society.)

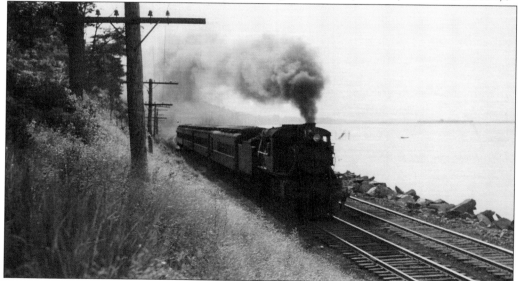

Between Atlantic Highlands and Highlands exists a thin thread of land along the base of the highest coastline points in America from there to Florida. At the water's edge, literally, the CNJ double-tracked through an area referred to as Hiltons. The station was nothing more than a shed and a long flight of steps. In July 1937, Camelback No. 622 has train No. 5313 from Atlantic Highlands to Bay Head. (Courtesy George E. Votava.)

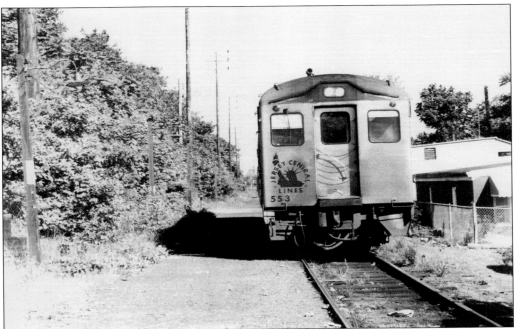

Expensive repairs caused by hurricanes caused passenger service to end between East Long Branch and Sea Bright by December 1945. Fort Hancock on Sandy Hook no longer needed rail service after World War II. As a result, Highlands became the end of the track. RDC No. 553 sits alone awaiting a few passengers for the northbound run. (Courtesy Railroad Avenue Enterprises.)

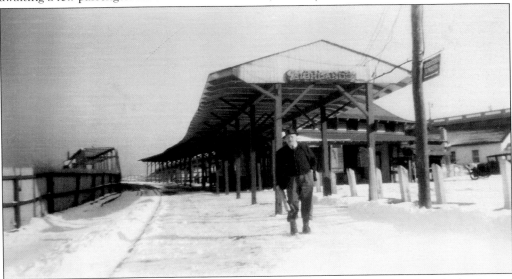

Highlands Station was located on the mainland side, on a curved elevated track at the beginning of a gauntlet track. This is a track arrangement that allowed two tracks to overlap but not become one set of tracks. Operationally, only one train could pass over this section at a time. Two tracks resumed on the other side of the bridge. This design helped reduce the cost of a two-track swing bridge and had less moving switch parts for snow to clog. George Lester Whitfield braves the cold with the station in the background. (Courtesy Tom Gallo.)

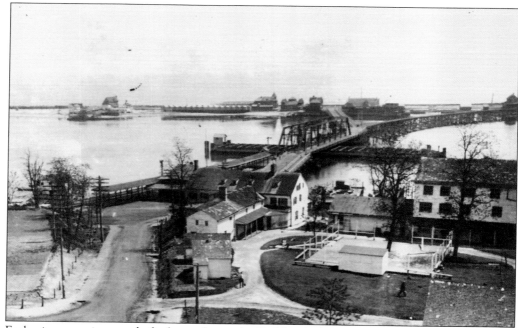

Early river crossings made for busy places. At Highlands the station is camouflaged by several stores. In the center is the famous CNJ swing span bridge over the Shrewsbury River. Nicknamed a scissor bridge due to its aerial appearance of an open pair of scissors, it provided a crossing for trains, horses and wagons, and pedestrian traffic, interrupted when great steamboats such as the *Sea Bird* passed through. (Courtesy Dorn's Classic Images.)

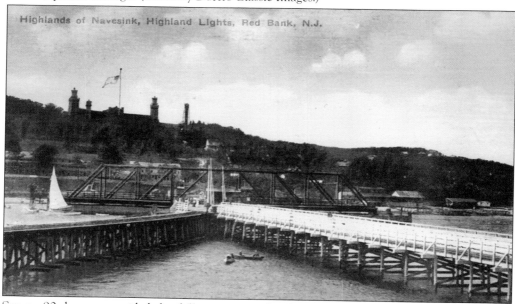

Highlands of Navesink, Highland Lights, Red Bank, N.J.

Swung 90 degrees provided the fullest opening for the bridge. The white fence trestle to the right carried horses and wagons to Sandy Hook. The track swung left (southward) to continue on along the sandy soil to stop at stations such as Galilee and Sea Bright. Crabbing was popular along the bridge pilings. (Courtesy Tom Gallo.)

SPECIAL TRAIN

FOR

VISITORS

Direct to Tent City

FORT HANCOCK

and Return

SUNDAYS, APRIL 12 & 19

Sandy Hook was the home of the U.S. military's Fort Hancock. In early years, it served as a fortress against sea attacks, later becoming a munitions proving ground. This activity in 1892 forced the CNJ's Sandy Hook service off the peninsula. The CNJ operated excursion trains to Fort Hancock during World War II, according to this excerpt from one of its flyers. Tent City was so named due to the numerous tents used as accommodations. (Courtesy Tom Gallo.)

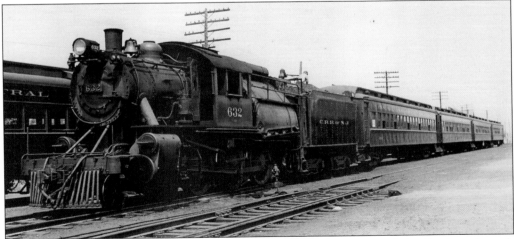

The end, or beginning depending on the direction of one's journey, of the Seashore branch was at East Long Branch. The CNJ's southern division headquarters building and a station were located here, where No. 632 with four cars rests on July 24, 1937. Passenger service to East Long Branch ended in 1945. This short segment received freight-only service into the 1960s. (Courtesy George E. Votava.)

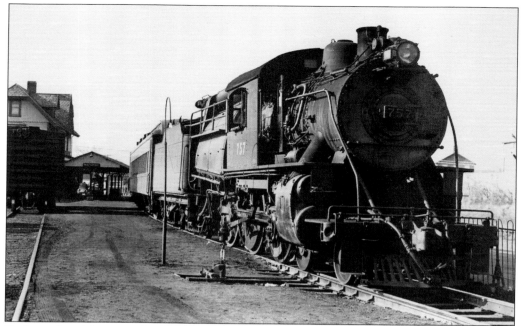

Back north at Matawan, the CNJ Freehold branch connected through the yard. With passenger service dwindling, a single coach was all that was needed. On February 14, 1953, Camelback No. 757 is idle until scheduled leaving time. The crew could be on the second floor of the station resting between runs. An express boxcar is on the stub track to be loaded with express mail that is presorted and does not require an RPO-type operation. (Courtesy George E. Votava.)

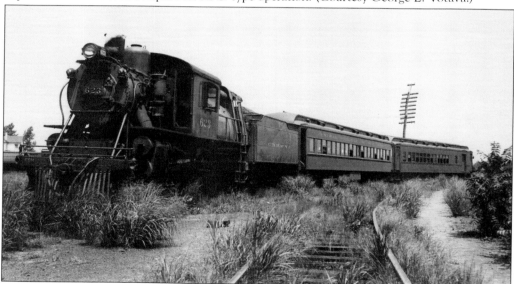

Sixteen years earlier, in 1936, a two-car train is enough for the service. Here on the wye at Matawan yard is No. 623 with a coach and combine. The engine cab is empty, indicating there is layover time before backing into the station. Discussions with employees about carrying milk cans in a combine have never confirmed it was done on this branch. Tickets noted baggage over 100 pounds required additional charges. (Courtesy George E. Votava.)

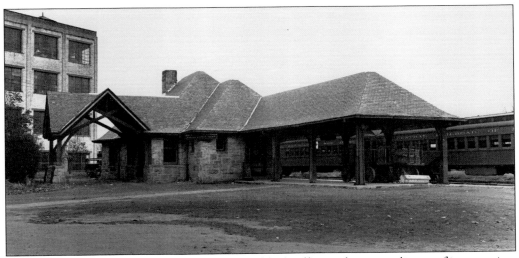

CNJ's Freehold station was a handsome stone block affair with a cascading roofline, portico, and continuous canopy shelter on the track side. The portico sheltered customers as they got off stagecoaches, keeping them dry. At the end of the building nearest the viewer was the railway express office. The baggage wagons can be seen at the canopy end. A corner of the landmark Karagheusian Rug Mill is visible to the left. (Courtesy Bob's Photos.)

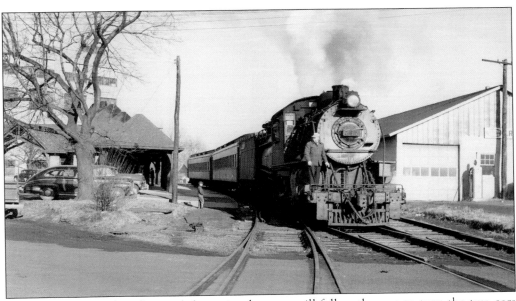

Now that everyone has departed the train, the crew will follow the wye to turn the two cars and Camelback No. 757 for the next trip east. A small boy watches the wheels and rods in motion as the barely visible conductor, under the canopy, calls the dispatcher as part of routine business. Passenger service ended on this branch on April 25, 1953. (Courtesy North Jersey Electric Railway Historical Society.)

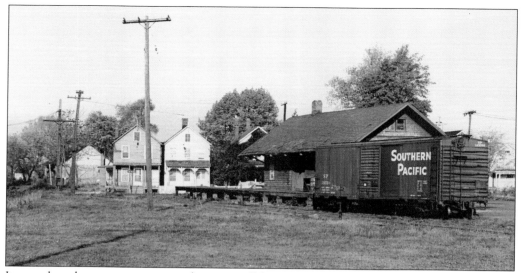

It must be a late warm season as the trees still have quite a few leaves in this November 1968 scene. The CNJ Freehold freight house has seen better maintenance days and busier times. On this day, one Southern Pacific boxcar, lightly loaded based on the truck's springs compression, seen with a magnifying glass, is all there is. The PRR F&J connection is just out of view to the left. (Courtesy William J. Coxey.)

WEEK-DAY TRAINS—NORTHBOUND | SUNDAYS

STATIONS	4902 3304	4902	4950	4904 4004	4100	4952 3384
Leave	A M	A M	A M	A M	A M	P M
Freehold	6.59	6.59	6.59	7.34	7 35	7.16
East Freehold	f7.03	f7.03	f7.03	f7.38	f7.39	f7.20
Marlboro	f7.07	f7.07	f7.07	7.42	7.44	7.24
Bradevelt	f7.11	f7.11	f7.11	f7.46	f7.47	f7.27
Wickatunk	f7.14	f7.14	f7.14	7.49	7.50	7.30
Morganville	f7.17	f7.17	f7.17	7.52	7.54	7.34
Freneau	7.21	7.21	7.21	7.56	7.58	7.38
Matawan { Ar.	7.26	7.26	7.26	8.01	8.02	7.43
Matawan { Lv.	7.30	7.32	7.32	8.04	8.04	7.48
South Amboy	7.41	7.41	8.18	8.17
Perth Amboy	7.47	7.47	8.23	8.23	7.58
Elizabethport....Ar.	8.17	8.17	8.28	8.45	8.14
Elizabeth........Ar.	8.42	8.42	8.42	8.35
Newark, Broad St..Ar.	8.45	8.39	8.45	8.33
Jackson Ave., J. C..Ar.	▲8 44	▲8.56	▲8 56	▲9.30	8.27
Jersey City Term....	8.09	8.37	8 44	8 43	9.08	8.34
New York Liberty-Cortlandt St...	8.22	8.50	8.56	8.55	9.20	8.46
Arrive	A M	A M	A M	A M	A M	P M

Vertical column notes: "See Note 1. Through train to Jersey City." — "Will not run holidays." — "See Note 2. Through train to Jersey City." — "HOLIDAYS ONLY." — "See Note 3." — "Will not run holidays." — "Through train to Jersey City."

Side panel: **MOTOR COACH SERVICE** — Regular Motor Coach service is maintained by the Rollo Transit Company between Matawan and Freehold.

This excerpt from a Freehold branch schedule dated November 15, 1941, shows weekday (includes Saturdays) northbound service. Train No. 4902 was the only "through" train going. The other required a connection at Matawan. The side panel notes "Motor Coach" service is maintained by the Rollo Transit Company. This service, contracted by the CNJ from Rollo, allowed selected trains to be discontinued, saving operational costs. (Courtesy Tom Gallo.)

The CNJ's southern division began at Red Bank, with a lead off the NY&LB. Light servicing of engines performed here was limited to fuel, water, and minor mechanical adjustments. The locomotives used in the outpost came down on through freights, utilizing them for pulling power and saving the cost of running them alone up to E'port. In May 1976, five diesels (one to the left) are serviced and ready. Two cabooses will protect QVX or one of the other drills. The scrap metal will be salvaged for revenue. (Courtesy Jim Boyle.)

A telephoto lens image makes the yard operation look crowded. The van to the left is a maintenance vehicle used by the track repairmen for line work. They are working in the yard (right). A drill and its crew (center) prepare to work around all the activity. Sitting freight cars cost money and lose revenue. (Courtesy Jim Boyle.)

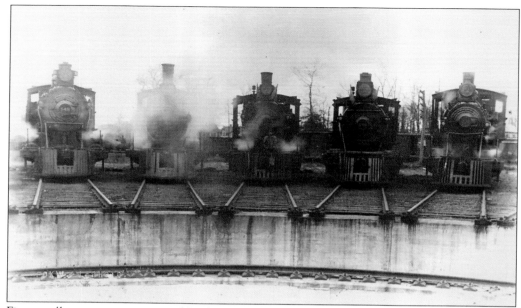

Five small steam engines resemble the items that fostered their occasional nicknames—tea kettles. With steam escaping and boiling away on their stub-ended turntable tracks with the pit in the foreground, these locomotives provided the pulling power for multidirectional drill jobs. He is hard to see, but a lone worker sits poised on the pilot of the center locomotive. (Courtesy Dorn's Classic Images.)

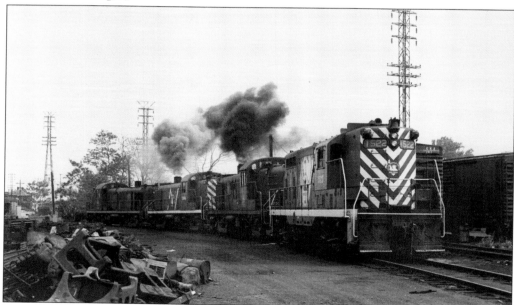

Someone has opened the throttle, sometimes done to test an engine and sometimes done for show. At least the last three units are MUs (electrically connected and operated from one locomotive) as they are simultaneously exhausting smoke, a common character of the ALCO-built RS3s. The GP7 No. 1522 is decked out in the 1972 red and white paint scheme of the CNJ, shedding its blue and yellow Baltimore and Ohio takeover shadow. (Courtesy Jim Boyle.)

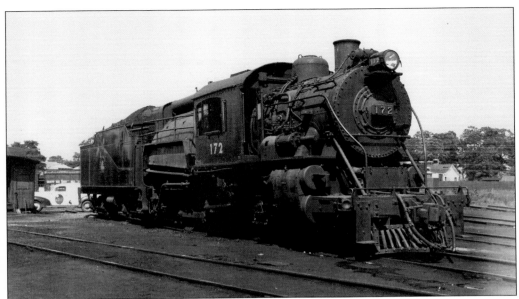

Camelback No. 172 is without fire either as a savings since it is unneeded for a while, or it may need to be shopped and towed to E'port. It rests on the turntable spurs awaiting whatever is in store. The coach end visible at left is a sample of retired coaches used as sheds and shops. This is a wooden coach, which required turn buckles underneath to compensate for sagging conditions. (Courtesy Frances Palmer.)

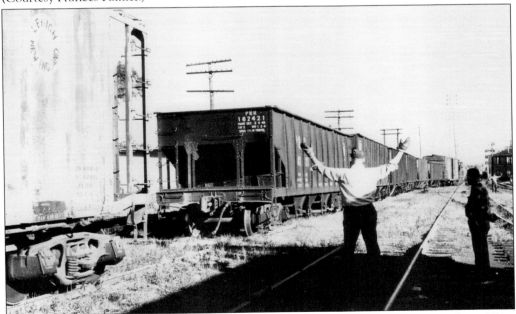

Members of a drill crew make up their own train from a list the yardmaster gave them. They must go back and forth and in and out of different tracks to assemble all the cars listed to be delivered on that run. A brakeman uses both hands to signal another brakeman six cars away. That brakeman has a better sight of the engineer, hidden by the curved track, who moves and stops the train by these hand signals. (Courtesy William B. Longo.)

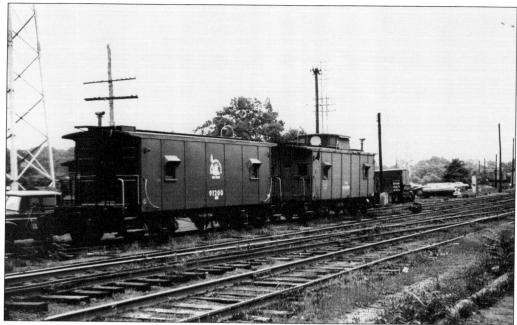

Making up a train included strategic placement of cars in an order that allowed easier drilling sequentially, as each customer's side track is reached as the train travels in one direction, then back to Red Bank the same day. Once the train was made up, the crew selected a caboose. No. 91200, without the cupola, was one of a kind but well known in this area. Both cabooses, the other No. 91369, are wood, indicating their ages. (Courtesy Tom Gallo.)

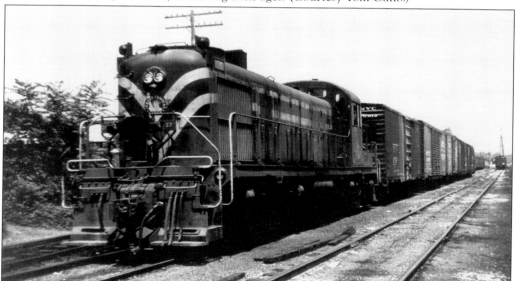

With the train made up, caboose in place, brakes tested, and signal set at green (proceed), the crew departs the yard for a short or sometimes long day. Crews' work hours were limited by regulations. If time ran out, a taxi or jitney would be sent to return the crew to home base. The next work day, they were brought back to the train to pick up where they left off. (Courtesy William B. Longo.)

Eatontown Station was also a junction point for the CNJ's branch to East Long Branch, passing by Fort Monmouth and through Branchport. In a rare view, CNJ Camelback No. 174 is pushing two open hoppers toward Fort Monmouth. The tracks are obscured by ground vegetation, an indication that movement over this section is limited. (Courtesy Tom Gallo.)

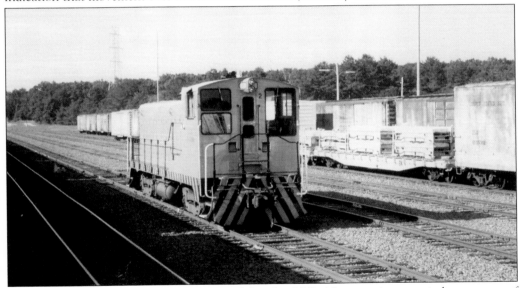

Naval Weapons Station Earle is operated by the U.S. Navy as its own in-house way of moving material around. On the occasion of this image, a public excursion was held, allowing photographers permission to record equipment and operations. USN No. 2, one of six Baldwin switchers in service, basks in the sun on the main track. Behind it are various boxcars, flatcars, and containers also owned and used by the navy. The CNJ delivered raw materials to the base. The PRR had trackage rights over the CNJ to Earle. (Courtesy Tom Gallo.)

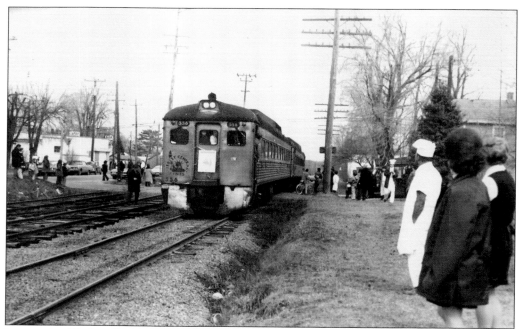

Just south of Earle at Farmingdale, an excursion has brought back passenger service for one day in March 1972. A pair of CNJ Budd RDCs, No. 556 and No. 551, stops at the famous Farmingdale House, an excellent restaurant. The chef himself, right, has left his kitchen, maybe in hopes of obtaining some of the recipes of those fine railroad dishes created by long-gone onboard chefs. (Courtesy John Brinckmann.)

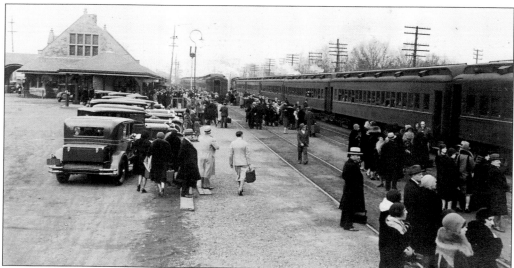

The Maxim station was in Howell Township, which marks the southern end of Monmouth County. Just over the boundary line is Lakewood, a prominent town. A well-appointed station building similar in construction material and style to Freehold, but much larger, made it clear the CNJ wanted the town's business. This busy time at the station with one train in place and another just west thereof shows the dress of the period and some new automobiles, a sign of prosperity and individual stature. (Courtesy Tom Gallo.)

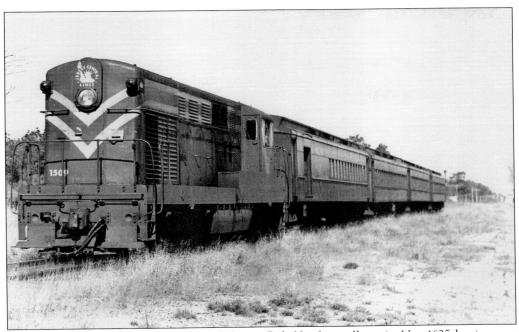

The Barnegat branch connected at Lakehurst. Bob Hoeft recalls train No. 4625 having one bundle of newspapers in the combine for Beachwood. On Fridays, there was one barrel of live lobsters on ice for Lakewood. Train No. 4606 carried only company mail. CNJ No. 1509 and its 1,600 horsepower and four cars are overdoing it for the lackluster level of business on this line in the early 1950s. The date of discontinuance of passenger service on the southern division was April 26, 1953. (Courtesy North Jersey Electric Railway Historical Society.)

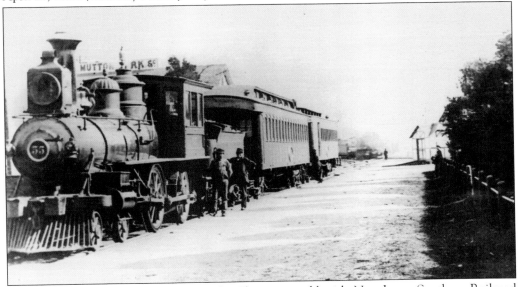

Engineer John Davis and fireman Charles Thomas stand beside New Jersey Southern Railroad (a subsidiary of the CNJ) engine No. 55 looking at the camera. The second car is a combine in this 1888 image where much of the habits of railroads were formed. This train is a Red Bank to Atlantic Highlands trip, joining at Belford on the Seashore branch. (Courtesy Tom Gallo.)

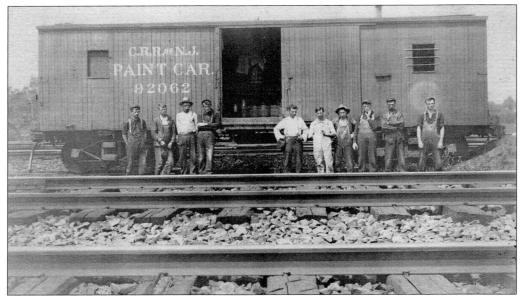

Much has been seen regarding railroad structures—stations, bridges, shanties, towers, and yard facilities. Someone had to maintain those structures. Here they are. The CNJ paint gang is in front of its own "shop on wheels" boxcar No. 92062, the paint car. Most maintenance of way material and crews traveled by extra train movement in older freight equipment. Even the payroll was doled out by a guarded train. A least one of the workers is smoking. With all those flammables, they need to paint a no smoking sign on the car. (Courtesy Tom Gallo.)

Likewise, one has seen miles of tracks—steel rails, wooden cross ties, signal masts, and so on. The diamonds noted took a pounding and wore quickly as train wheel flanges hit in opposing directions. At Red Bank, on the diamond, CNJ veteran employee and welder Louis Burno torches out bolts so the frog, the crossover point of the diamond rails, can be changed out as it is beyond rebuilding. (Courtesy Tom Gallo.)

Four

THE BLUE COMET

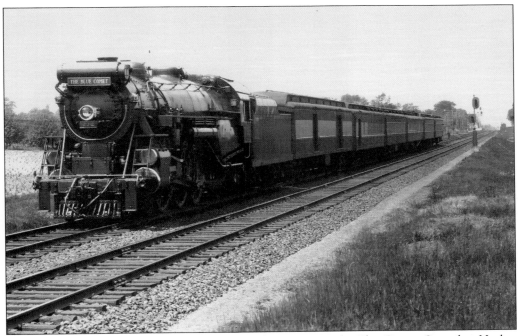

Last but not least is the CNJ's most remembered train name, the *Blue Comet*. Staged at Hazlet, its high polish shines for the camera. Steam locomotives referred to as Pacifics, in this case CNJ No. 832, were assigned. The train featured first-class service at regular fares, an innovation at the time, deliciously prepared foods on board, a lounge for all, and service beyond the imagination. Designed and built in-house under a shroud of secrecy, the train began service on February 21, 1929. It operated between Jersey City and Atlantic City in competition with PRR trains from New York to America's playground by the Atlantic Ocean. It was conceived by CNJ's president Roy B. White. The colors selected represented the restful blue sky and ocean with the crème-tinted warmness of a sandy beach. Residents knew of the *Blue Comet*'s passing, and claims were made they could set their watches by it. (Courtesy Tom Gallo.)

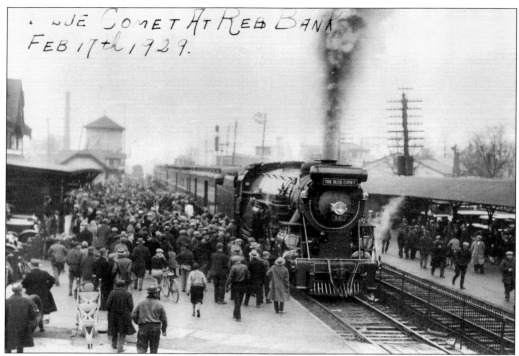

On a publicity run, Pacific No. 831 blows its stack for the crowd as people gather for the show. Painted in a blue and cream scheme throughout, each coach was named for a short-period comet, which was the fastest of comets. The train in fast motion was to portray to the eye a vision of a streaking comet. The locomotives themselves were attractively painted. Even connecting buses wore the Blue Comet motif. The Depression did much to affect patronage. (Courtesy Tom Gallo.)

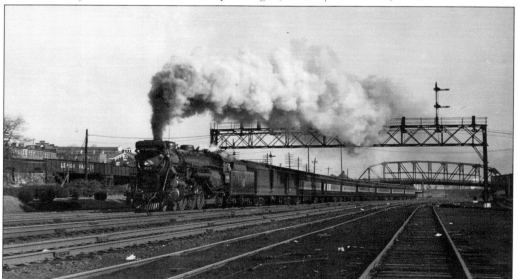

Pacific No. 833 gets everything rolling out of Jersey City terminal on November 14, 1937. There are eight cars on the train today, three not in Blue Comet paint. As ridership declined, equipment occasionally had regular cars and locomotives assigned. (Courtesy George E. Votava.)

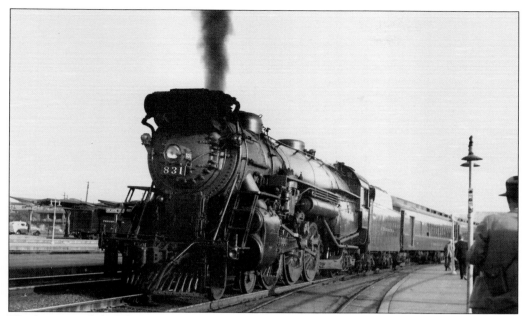

The last trip of the *Blue Comet* was on September 27, 1941. Pacific No. 831 did the honors as photographers recorded a diminishing era. Nationwide other railroad-named trains would follow suit. (Courtesy John Brinckmann.)

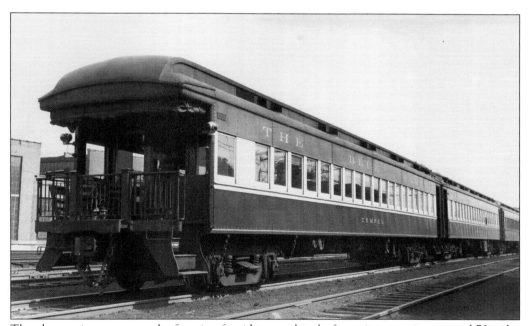

The observation cars were the favorites for riding on the platforms in open air at a good 70 miles per hour before open-cockpit airplane rides became common. Neat and cleaned for excursion service, the cars played further roles after the Comet's demise, for example a public diner, a crew base, and a private club car. (Courtesy Tom Gallo.)

The *Blue Comet* did not escape the mishaps of other regular trains. After a heavy rainfall soaked the sandy soils of South Jersey, the train derailed at speed at Chatsworth on August 19, 1939. No one was killed. In the isolated area, it took time for recovery to occur. This aerial photograph makes the cars appear to look like toys. (Courtesy Ed Brown.)

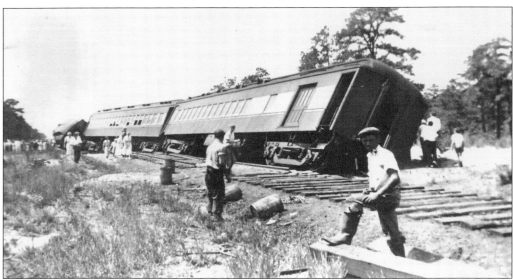

The next day, everyone pitched in to begin the recovery operation. A CNJ rail crane was brought in, placing one piece of equipment at a time back on temporary rails so it could be sent to the shops for rebuilding. (Courtesy John Brinckmann.)

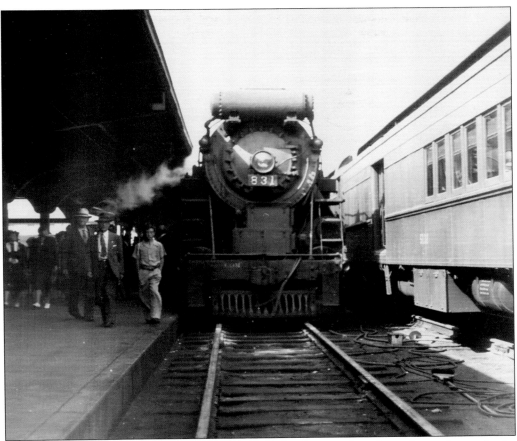

After repairs, the train continued to operate. Here for one last time, the train awaits its northbound departure from Atlantic City. (Courtesy John Brinckmann.)

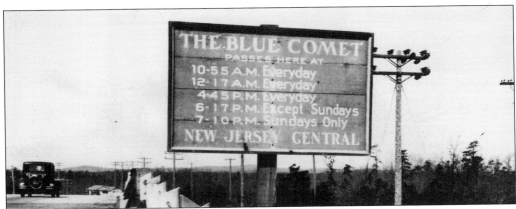

This sign was located on the Highway 34 bridge over the CNJ southern division. The sign states that the *Blue Comet* passes here at "10-55 A.M. Everyday / 12-17 A.M. [should be P.M.] Everyday / 4-45 P.M. Everyday / 6-17 P.M. Except Sundays / 7–10 P.M. Sundays Only / New Jersey Central." However, the *Blue Comet* does not pass here anymore. (Courtesy Tom Gallo.)

DISCOVER THOUSANDS OF LOCAL HISTORY BOOKS FEATURING MILLIONS OF VINTAGE IMAGES

Arcadia Publishing, the leading local history publisher in the United States, is committed to making history accessible and meaningful through publishing books that celebrate and preserve the heritage of America's people and places.

Find more books like this at
www.arcadiapublishing.com

Search for your hometown history, your old stomping grounds, and even your favorite sports team.

Consistent with our mission to preserve history on a local level, this book was printed in South Carolina on American-made paper and manufactured entirely in the United States. Products carrying the accredited Forest Stewardship Council (FSC) label are printed on 100 percent FSC-certified paper.

MADE IN THE USA